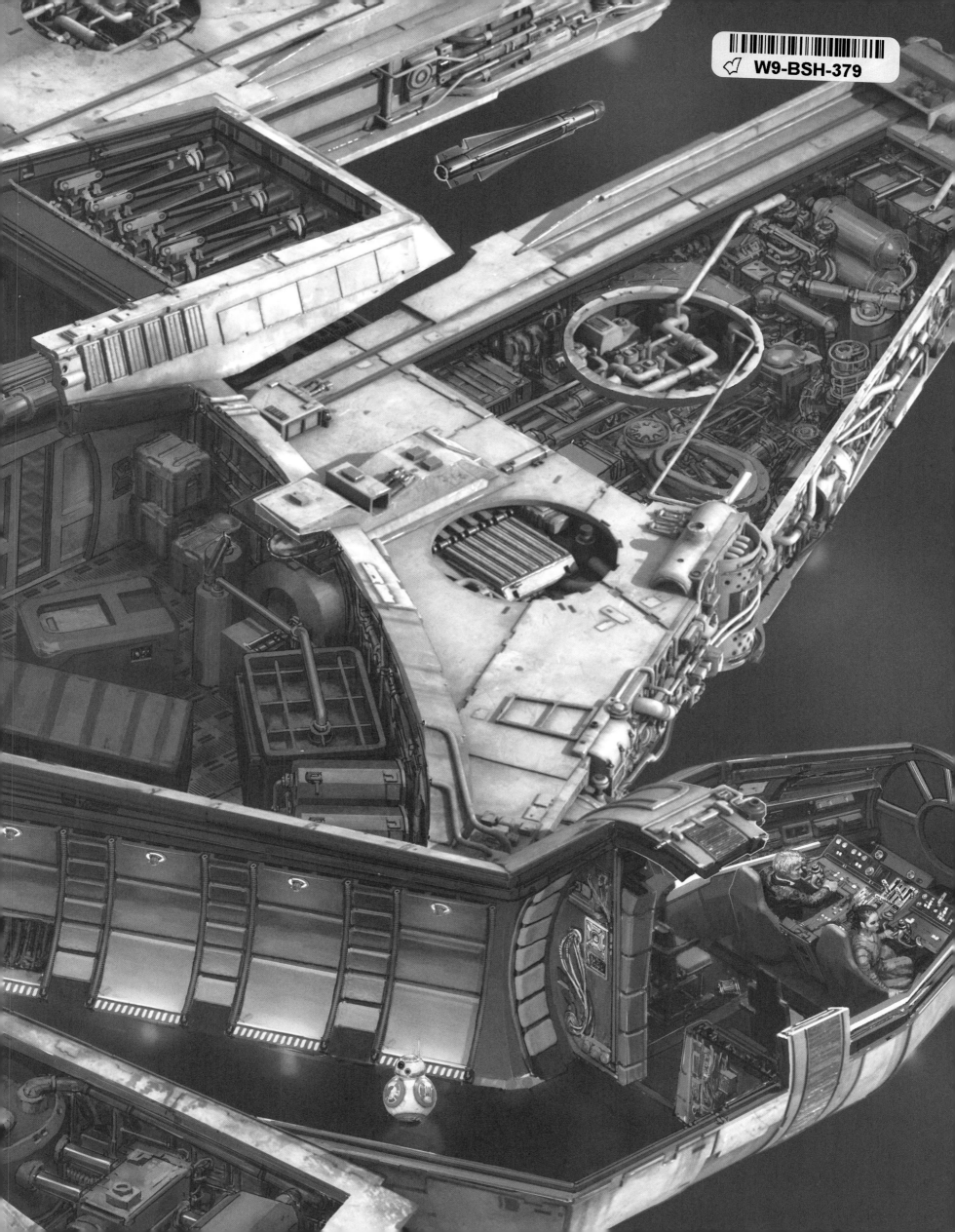

STAR WARS

THE FORCE AWAKENS

INCREDIBLE CROSS-SECTIONS

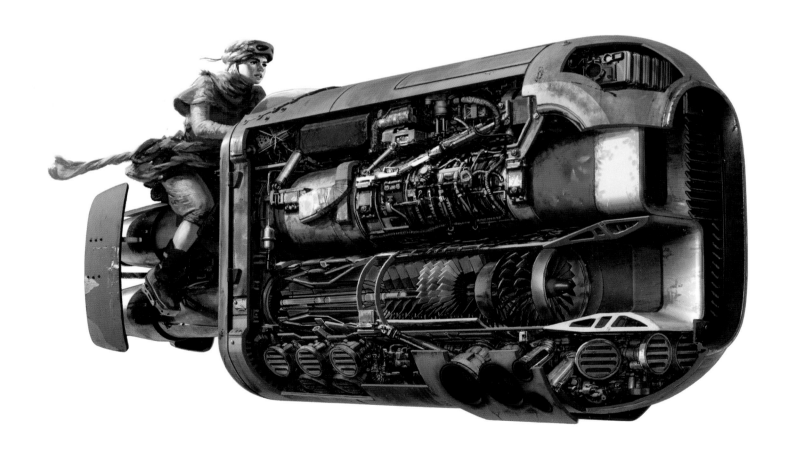

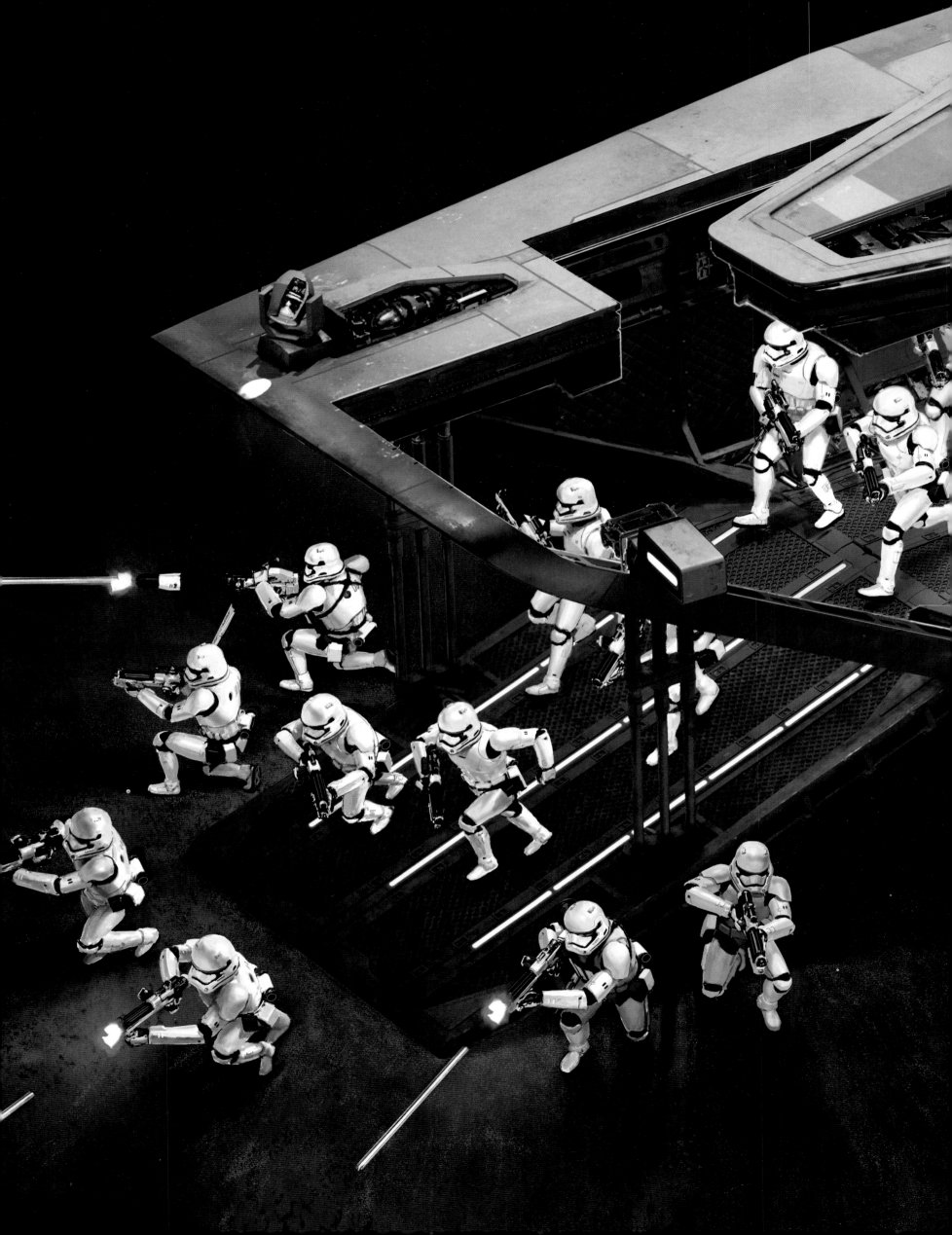

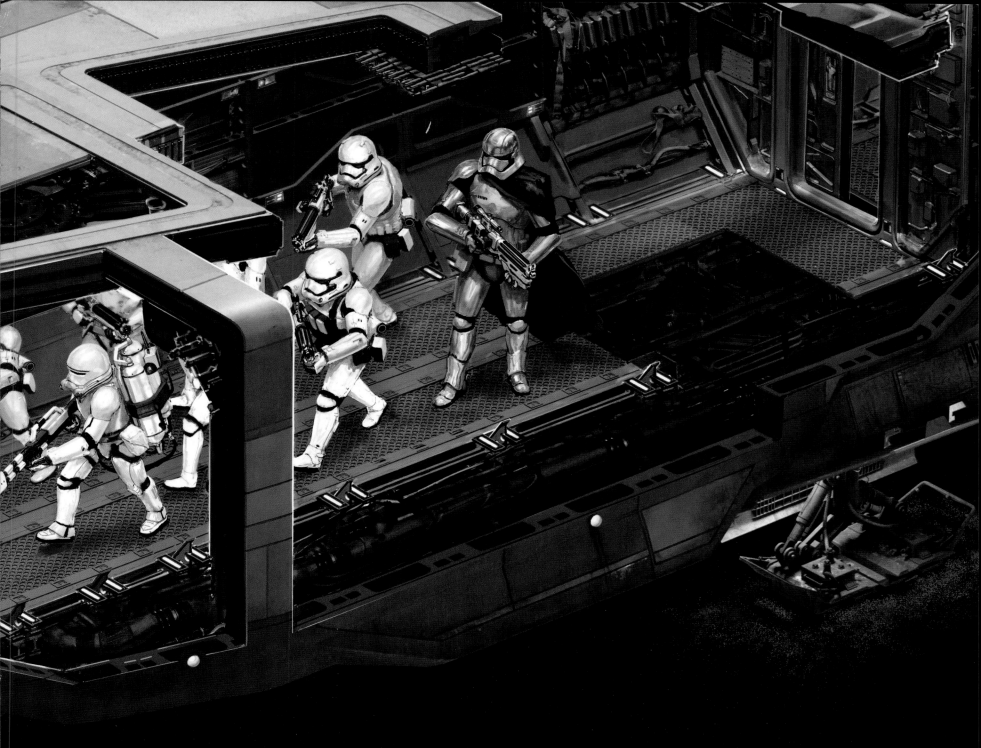

STAR WARS

THE FORCE AWAKENS
INCREDIBLE CROSS-SECTIONS

ILLUSTRATED BY KEMP REMILLARD • WRITTEN BY JASON FRY

CONTENTS

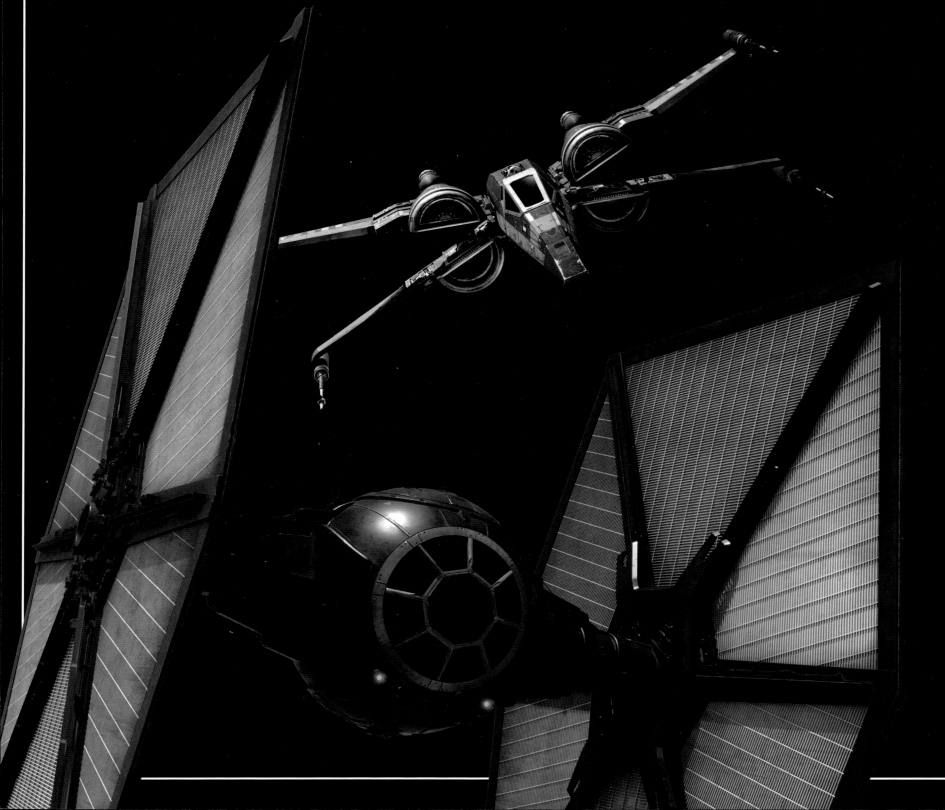

INTRODUCTION

GALACTIC CIVILIZATION relies on technologies that have existed for millennia. Faster-than-light communication and travel are routine, and even commonplace devices often boast vast amounts of computing power. Droids serve as cheap and expendable labor on countless planets, taking myriad forms to perform tasks too complicated, dangerous, or tedious for their organic masters. The galaxy's factions also have access to weapons of terrifying power, and defensive capabilities meant to neutralize them. Throughout the long history of the galaxy, war has always spurred technological innovation. The galaxy now finds itself on the cusp of a new conflict that will prove no exception. The First Order has risen from the ruins of the Galactic Empire, and mobilizes for war with the New Republic, armed with the horrific products of its secret research laboratories.

VEHICLE TECHNOLOGY

HYPERDRIVES

Hyperdrives allow ships to travel faster than light, crossing the void between stars through the alternate dimension of hyperspace. Hypermatter particles hurl a ship into hyperspace while preserving its mass/energy profile, sending it along a programmed course until it drops back into normal space at its destination. Large objects in normal space cast "mass shadows" in hyperspace, so hyperspace jumps must be precisely calculated to avoid deadly collisions.

GRAVITY

A number of galactic technologies work by manipulating gravity. Repulsorlifts allow a craft to hover or fly over a planet's surface by pushing against its gravity, producing thrust, while acceleration compensators keep starship crews alive during high-speed maneuvers. Tractor beams manipulate gravitational forces to push or pull objects, while interdiction fields create gravitational shadows that interfere with faster-than-light travel, pinning ships in normal space or yanking them out of hyperspace.

SENSORS

Sensors gather information about the area surrounding a vehicle, highlighting threats and hazards. Passive-mode sensors repeatedly scan the same area, scan-mode sensors have a longer range and collect data by emitting pulses in all directions, and search-mode sensors focus on a specific area for analysis. Data accumulated from scans is then fed into a sensor computer and relayed to a vehicle's operator. Most starships have sensor suites that analyze a wide range of spectra.

ENERGY WEAPONS

Laser cannons and turbolasers are based on the same principle as handheld blasters: energy-rich gas is converted to a glowing particle beam that can melt through targets. The largest such weapons are powerful enough to crack a planet's core. Starships also use ion cannons, which overwhelm electronic systems with ionized energy bursts, and physical ordnance such as concussion missiles and proton torpedoes, whose energy warheads release clouds of high-velocity proton particles.

POWER SOURCES

Vehicles use a range of power technologies, most of which date back to the Republic's earliest days. The most common are chemical, fission, or fusion reactors, which consume a variety of fuels based on local resources. Large starships opt for fusion systems that contain hypermatter-annihilation cores, generating vast amounts of power. Many starship fuels are hazardous to organic beings, circulating in ship systems as corrosive liquids or combustible and poisonous gases.

SHIELDS

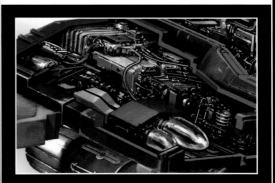

Shields are protective force fields that repel solid objects or absorb energy. Concussion shields repel space debris, while two varieties of deflector shield protect craft in battle. Ray shields deflect or scatter energy beams, while particle shields diffuse impacts from high-velocity projectiles and proton weapons. A shield's intensity gradually diminishes with distance from its projector. Most starships use a combination of ray and particle shielding for the most reliable protection.

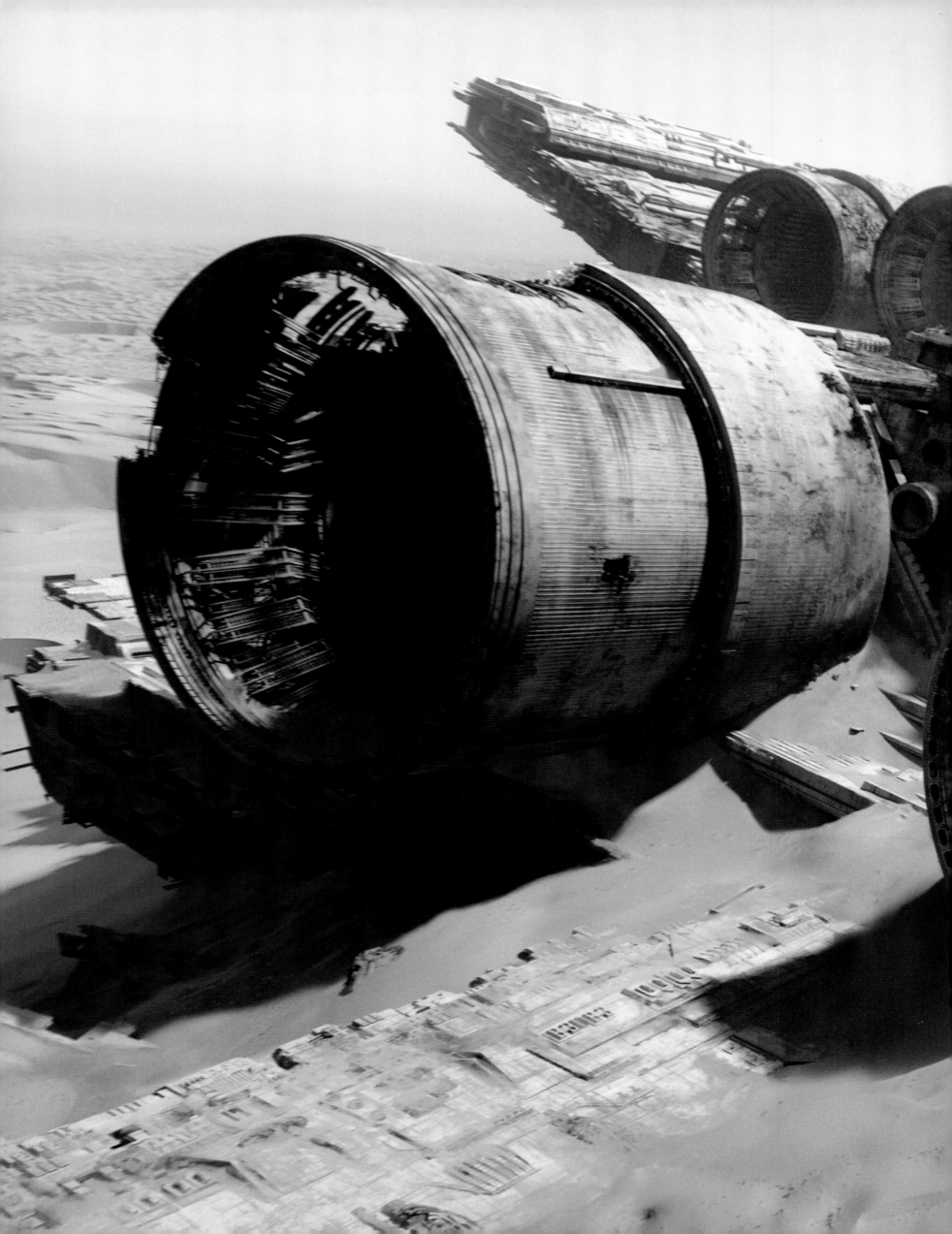

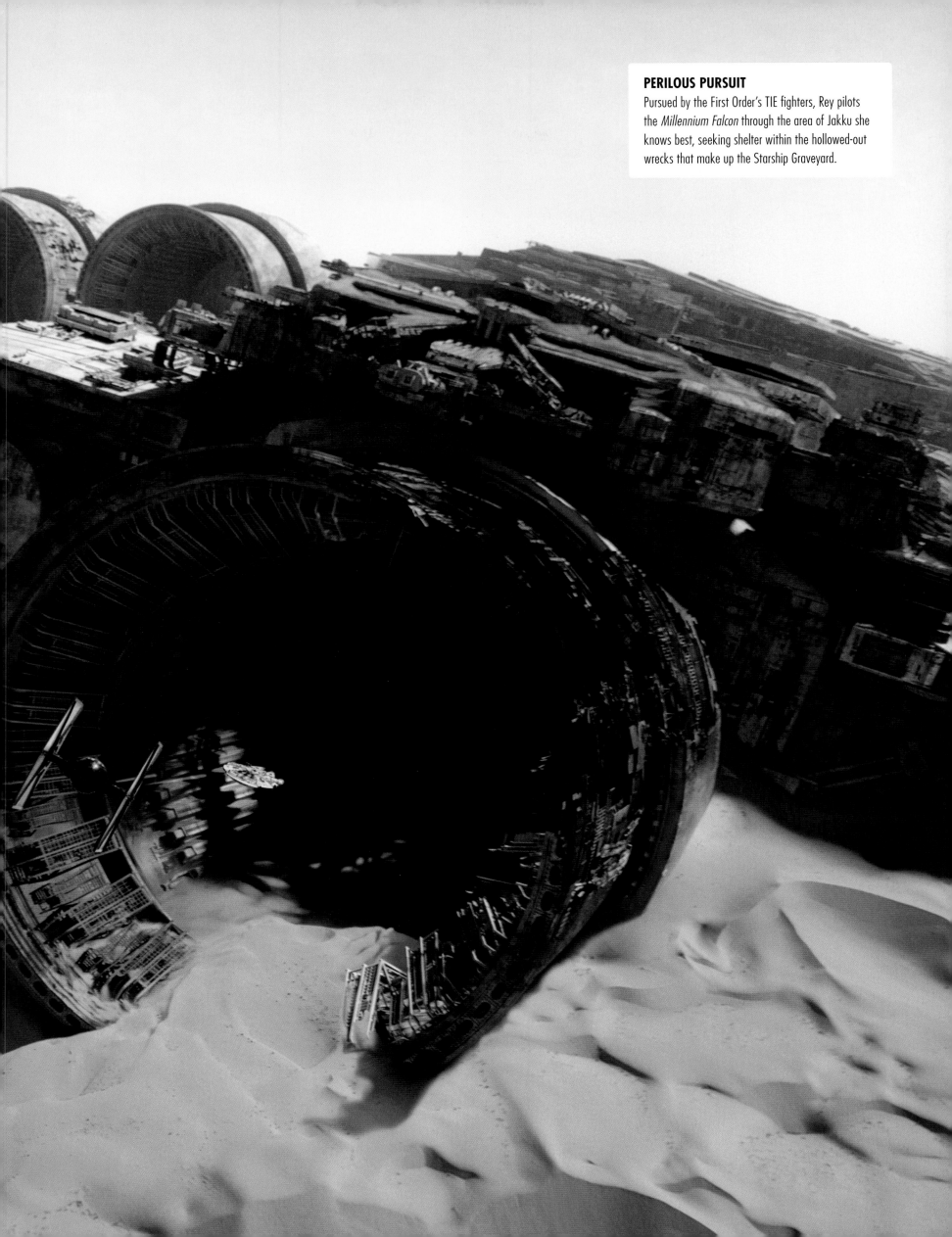

PERILOUS PURSUIT
Pursued by the First Order's TIE fighters, Rey pilots the *Millennium Falcon* through the area of Jakku she knows best, seeking shelter within the hollowed-out wrecks that make up the Starship Graveyard.

STORMTROOPER TRANSPORT

THE FIRST ORDER'S stormtroopers know no family except their fellow soldiers, and have trained from childhood with a variety of weapons, practicing combat tactics until they can execute any military maneuver with unthinking precision. The First Order's assault landers can deliver two full squads of troopers to the battlefield for ground operations. These no-frills vehicles ferry troops from orbit and forward bases to drop zones, then return when combat is complete to pick up the survivors. For defense, assault landers rely on their shields, tough armor, and a single gunner occupying a dorsal turret.

BATTLEFIELD VIEW

A pilot guides the assault lander to its drop zone from a cockpit elevated for maximum visibility. As veterans of duty in TIE fighters, assault lander pilots are not troubled by this exposed vantage point, though they do complain that the landers are far less maneuverable than starfighters. If the pilot's control connections are severed, the assault lander can also be flown from a console inside the craft, but this backup system offers far less precision than the primary controls.

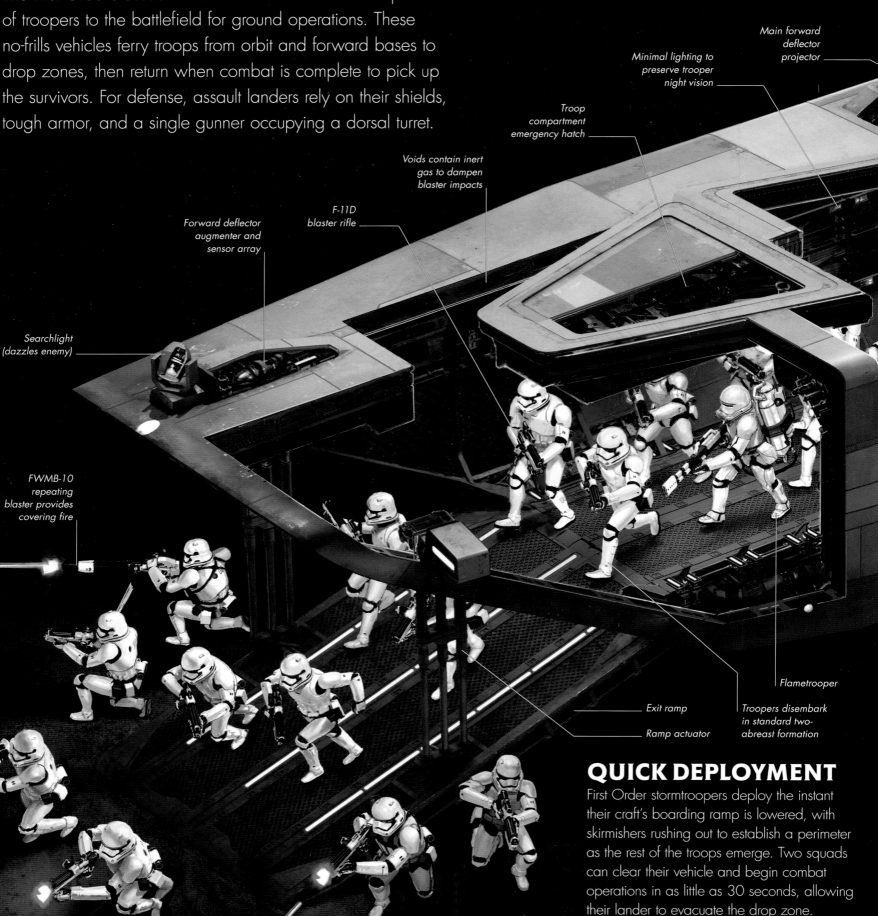

Main forward deflector projector

Minimal lighting to preserve trooper night vision

Troop compartment emergency hatch

Voids contain inert gas to dampen blaster impacts

F-11D blaster rifle

Forward deflector augmenter and sensor array

Searchlight (dazzles enemy)

FWMB-10 repeating blaster provides covering fire

Flametrooper

Exit ramp

Troopers disembark in standard two-abreast formation

Ramp actuator

QUICK DEPLOYMENT

First Order stormtroopers deploy the instant their craft's boarding ramp is lowered, with skirmishers rushing out to establish a perimeter as the rest of the troops emerge. Two squads can clear their vehicle and begin combat operations in as little as 30 seconds, allowing their lander to evacuate the drop zone.

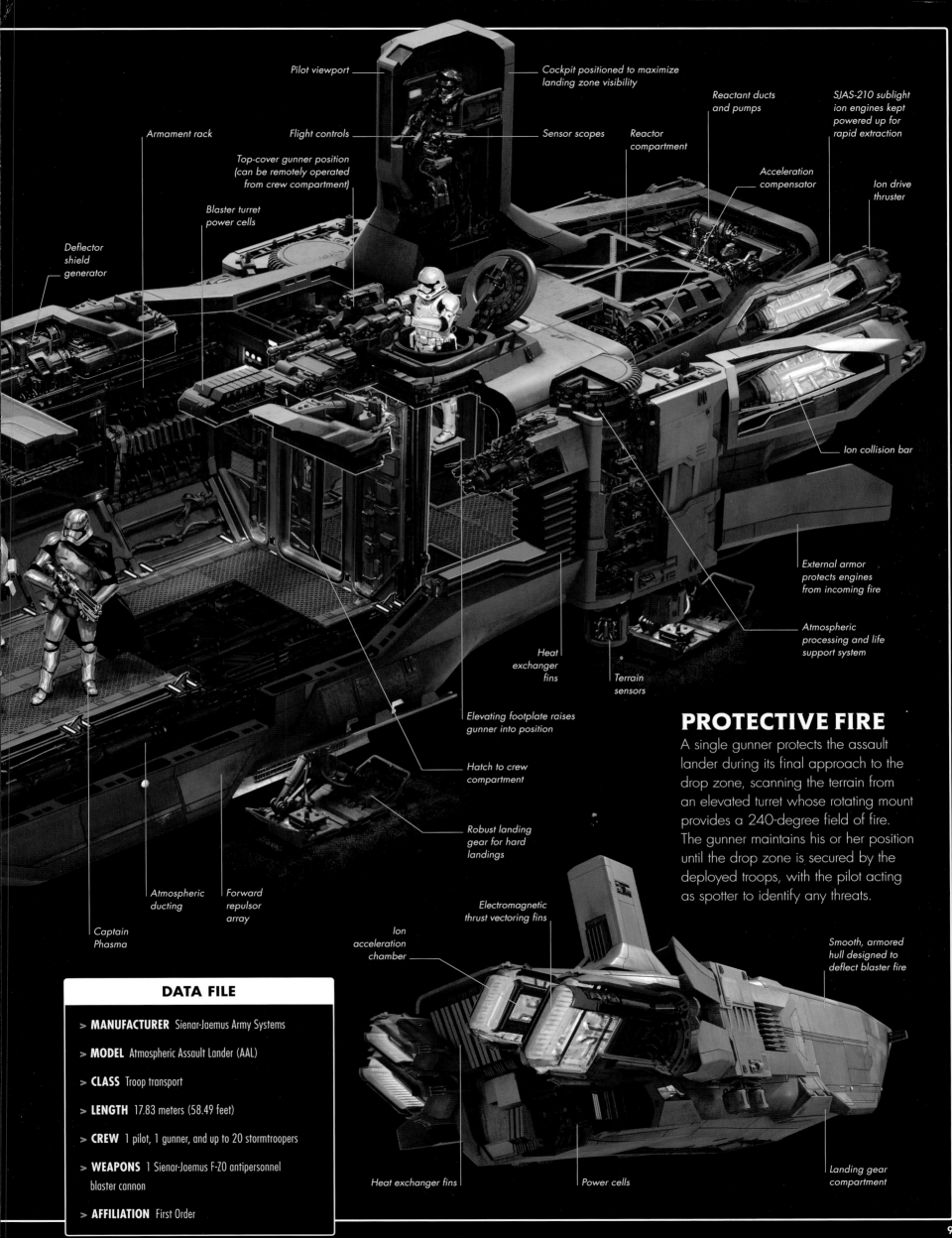

Pilot viewport

Cockpit positioned to maximize
landing zone visibility

Reactant ducts
and pumps

SJAS-210 sublight
ion engines kept
powered up for
rapid extraction

Armament rack

Flight controls

Sensor scopes

Reactor
compartment

Acceleration
compensator

Ion drive
thruster

Top-cover gunner position
(can be remotely operated
from crew compartment)

Blaster turret
power cells

Deflector
shield
generator

Ion collision bar

External armor
protects engines
from incoming fire

Atmospheric
processing and life
support system

Heat
exchanger
fins

Terrain
sensors

Elevating footplate raises
gunner into position

Hatch to crew
compartment

PROTECTIVE FIRE

A single gunner protects the assault
lander during its final approach to the
drop zone, scanning the terrain from
an elevated turret whose rotating mount
provides a 240-degree field of fire.
The gunner maintains his or her position
until the drop zone is secured by the
deployed troops, with the pilot acting
as spotter to identify any threats.

Atmospheric
ducting

Forward
repulsor
array

Robust landing
gear for hard
landings

Captain
Phasma

Electromagnetic
thrust vectoring fins

Ion
acceleration
chamber

Smooth, armored
hull designed to
deflect blaster fire

DATA FILE

> **MANUFACTURER** Sienar-Jaemus Army Systems

> **MODEL** Atmospheric Assault Lander (AAL)

> **CLASS** Troop transport

> **LENGTH** 17.83 meters (58.49 feet)

> **CREW** 1 pilot, 1 gunner, and up to 20 stormtroopers

> **WEAPONS** 1 Sienar-Jaemus F-Z0 antipersonnel
blaster cannon

> **AFFILIATION** First Order

Heat exchanger fins

Power cells

Landing gear
compartment

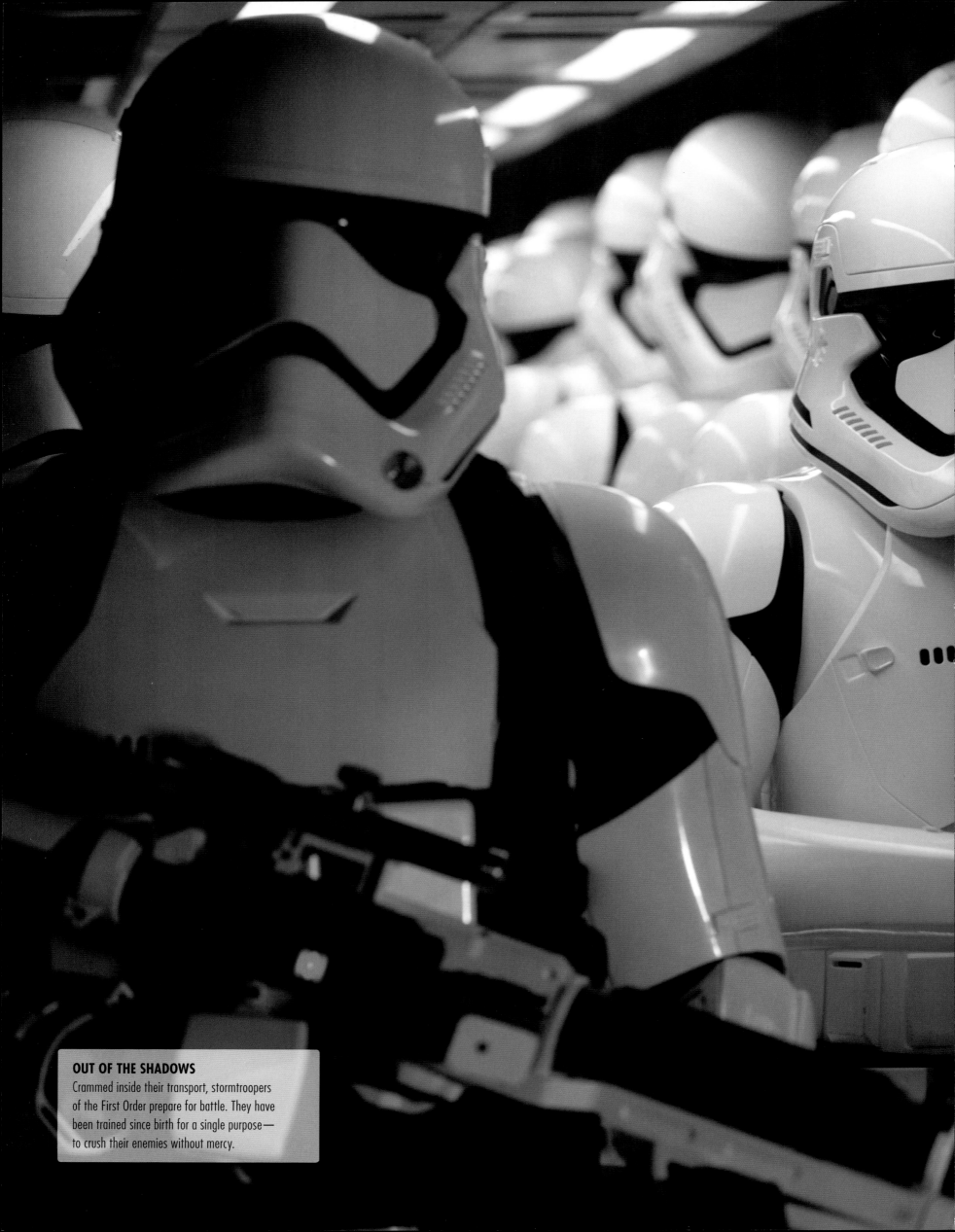

OUT OF THE SHADOWS
Crammed inside their transport, stormtroopers of the First Order prepare for battle. They have been trained since birth for a single purpose— to crush their enemies without mercy.

POE'S X-WING

THE T-70 X-WING is a favorite craft of Resistance pilots, including Poe Dameron, who flies a customized example codenamed *Black One*. The latest incarnation of the venerable X-wing family, the T-70 is faster than the ships that formed the backbone of the Alliance's starfighter corps during the Galactic Civil War and is equipped with more powerful weapons. X-wings are more expensive and complex than the First Order's TIE fighters, but much more versatile. They are nimble enough for dogfighting but powerful enough to slug it out with enemy capital ships.

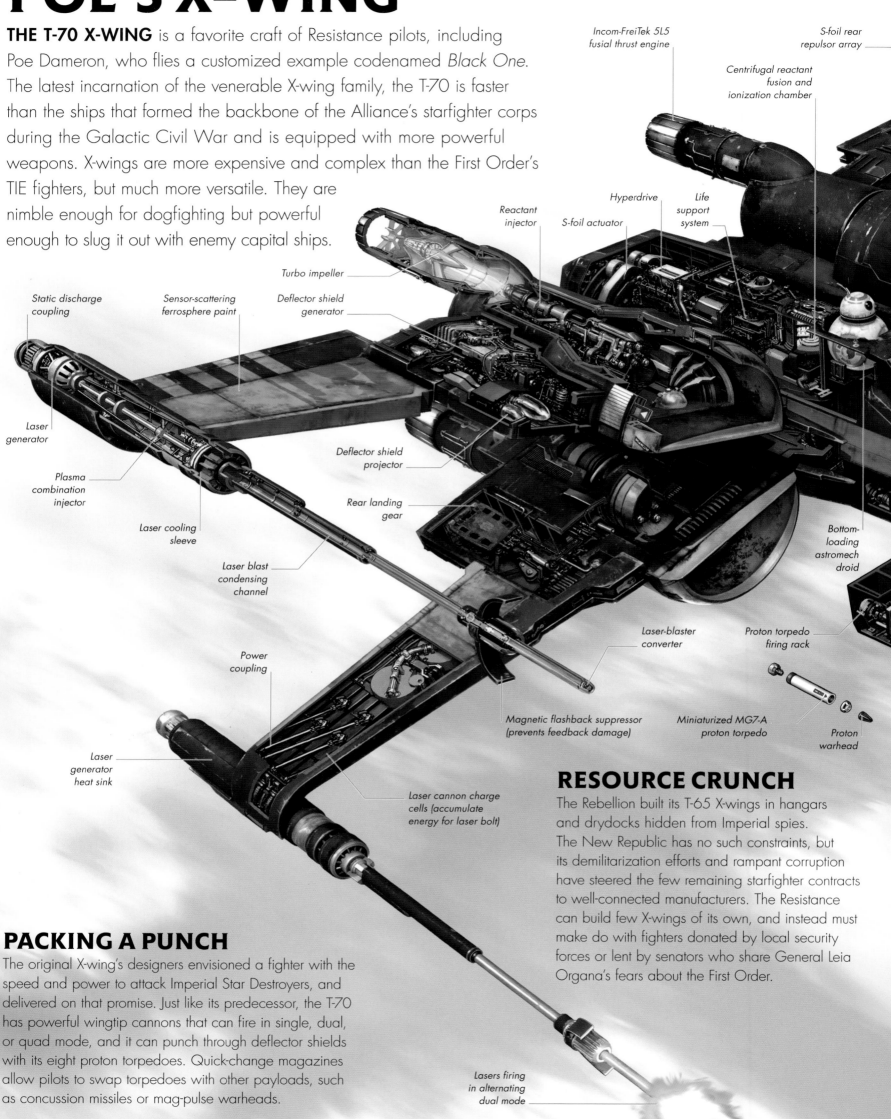

Incom-FreiTek 5L5 fusial thrust engine

S-foil rear repulsor array

Centrifugal reactant fusion and ionization chamber

Hyperdrive

Life support system

Reactant injector

S-foil actuator

Turbo impeller

Static discharge coupling

Sensor-scattering ferrosphere paint

Deflector shield generator

Laser generator

Deflector shield projector

Plasma combination injector

Laser cooling sleeve

Rear landing gear

Laser blast condensing channel

Bottom-loading astromech droid

Power coupling

Laser-blaster converter

Proton torpedo firing rack

Laser generator heat sink

Laser cannon charge cells (accumulate energy for laser bolt)

Magnetic flashback suppressor (prevents feedback damage)

Miniaturized MG7-A proton torpedo

Proton warhead

Laser generator

Lasers firing in alternating dual mode

PACKING A PUNCH

The original X-wing's designers envisioned a fighter with the speed and power to attack Imperial Star Destroyers, and delivered on that promise. Just like its predecessor, the T-70 has powerful wingtip cannons that can fire in single, dual, or quad mode, and it can punch through deflector shields with its eight proton torpedoes. Quick-change magazines allow pilots to swap torpedoes with other payloads, such as concussion missiles or mag-pulse warheads.

RESOURCE CRUNCH

The Rebellion built its T-65 X-wings in hangars and drydocks hidden from Imperial spies. The New Republic has no such constraints, but its demilitarization efforts and rampant corruption have steered the few remaining starfighter contracts to well-connected manufacturers. The Resistance can build few X-wings of its own, and instead must make do with fighters donated by local security forces or lent by senators who share General Leia Organa's fears about the First Order.

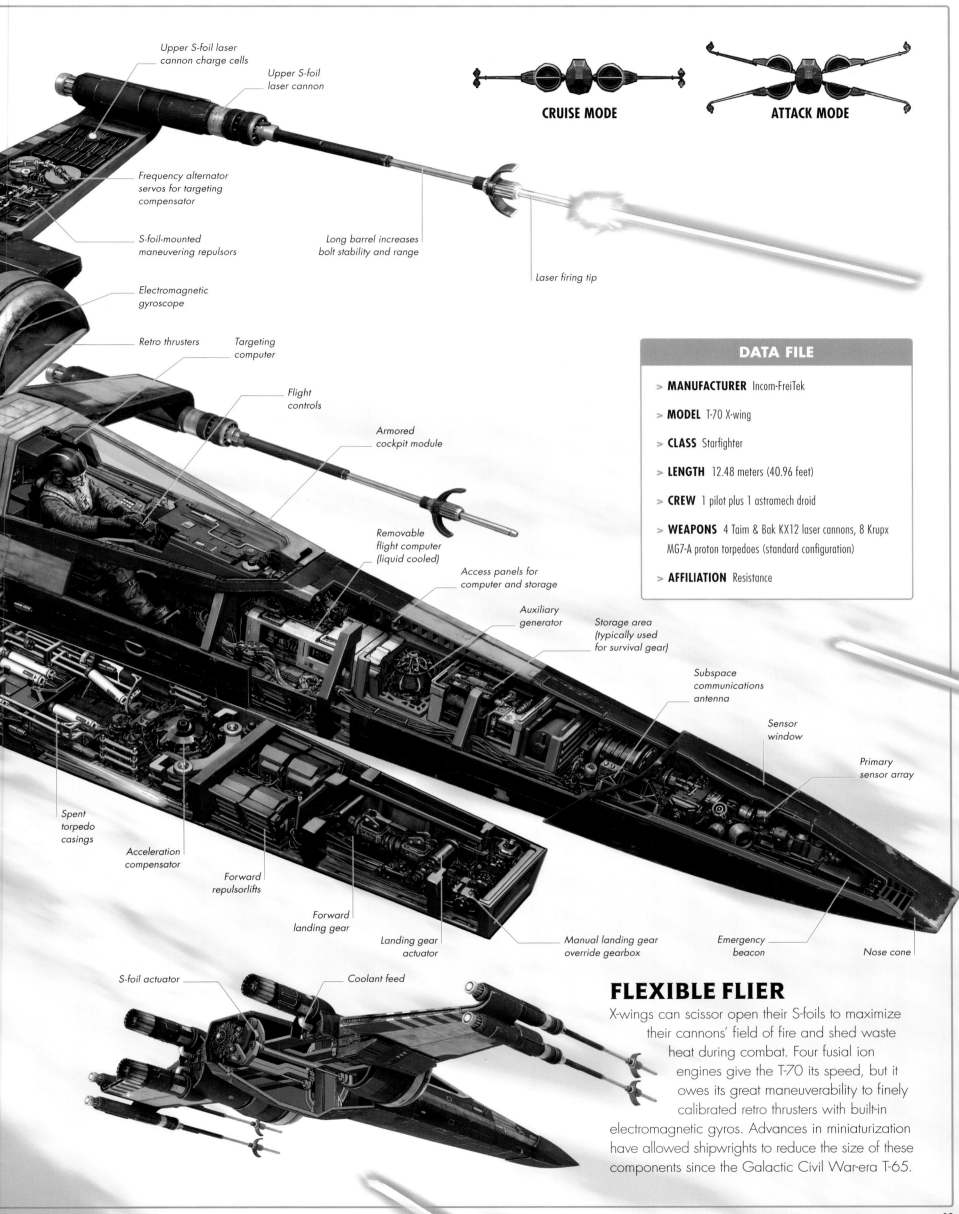

Upper S-foil laser
cannon charge cells

Upper S-foil
laser cannon

Frequency alternator
servos for targeting
compensator

S-foil-mounted
maneuvering repulsors

Long barrel increases
bolt stability and range

Laser firing tip

Electromagnetic
gyroscope

CRUISE MODE

ATTACK MODE

Retro thrusters

Targeting
computer

Flight
controls

Armored
cockpit module

Removable
flight computer
(liquid cooled)

Access panels for
computer and storage

Auxiliary
generator

Storage area
(typically used
for survival gear)

Subspace
communications
antenna

Sensor
window

Primary
sensor array

Spent
torpedo
casings

Acceleration
compensator

Forward
repulsorlifts

Forward
landing gear

Landing gear
actuator

Manual landing gear
override gearbox

Emergency
beacon

Nose cone

S-foil actuator

Coolant feed

DATA FILE

> **MANUFACTURER** Incom-FreiTek

> **MODEL** T-70 X-wing

> **CLASS** Starfighter

> **LENGTH** 12.48 meters (40.96 feet)

> **CREW** 1 pilot plus 1 astromech droid

> **WEAPONS** 4 Taim & Bak KX12 laser cannons, 8 Krupx
MG7-A proton torpedoes (standard configuration)

> **AFFILIATION** Resistance

FLEXIBLE FLIER

X-wings can scissor open their S-foils to maximize
their cannons' field of fire and shed waste
heat during combat. Four fusial ion
engines give the T-70 its speed, but it
owes its great maneuverability to finely
calibrated retro thrusters with built-in
electromagnetic gyros. Advances in miniaturization
have allowed shipwrights to reduce the size of these
components since the Galactic Civil War-era T-65.

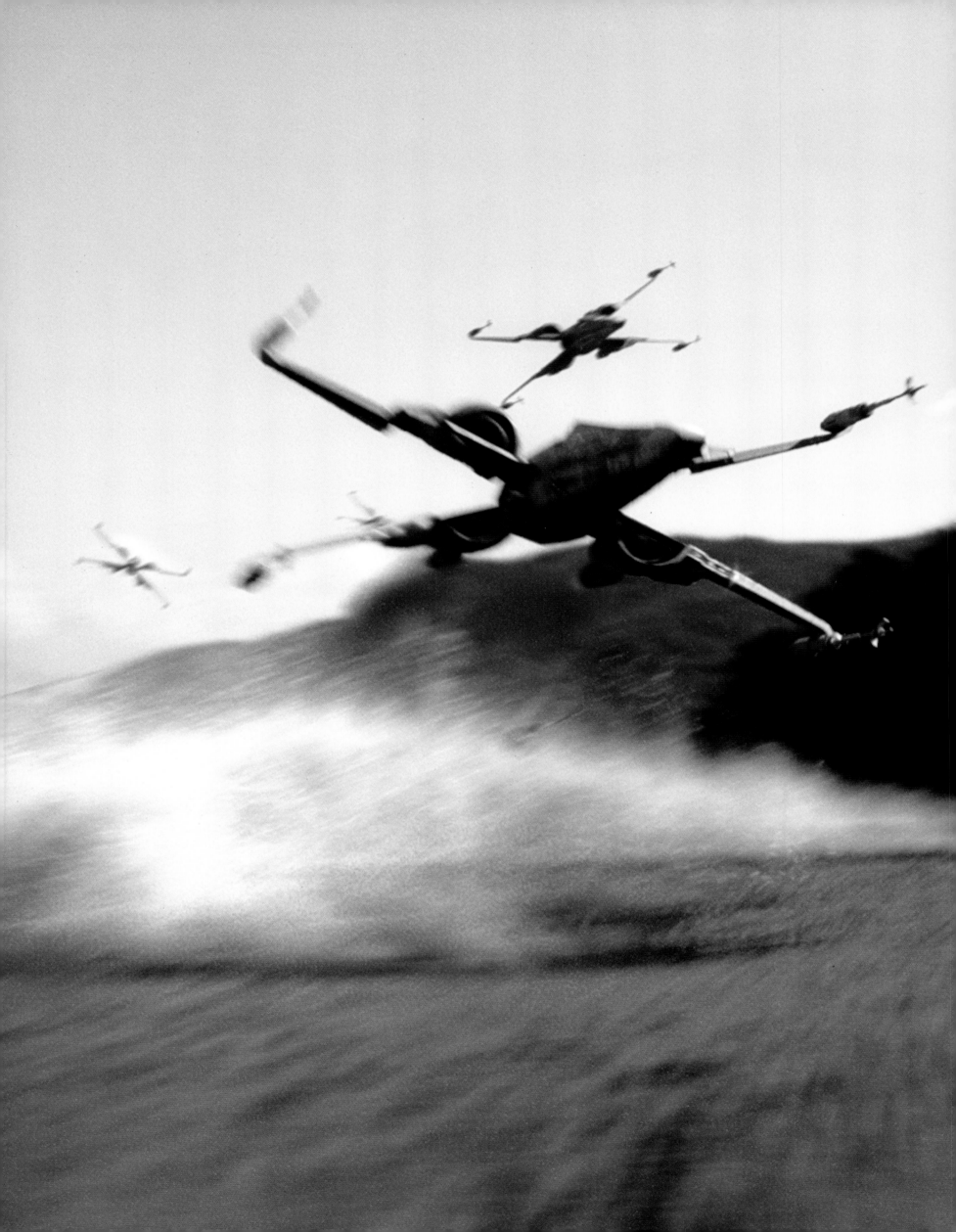

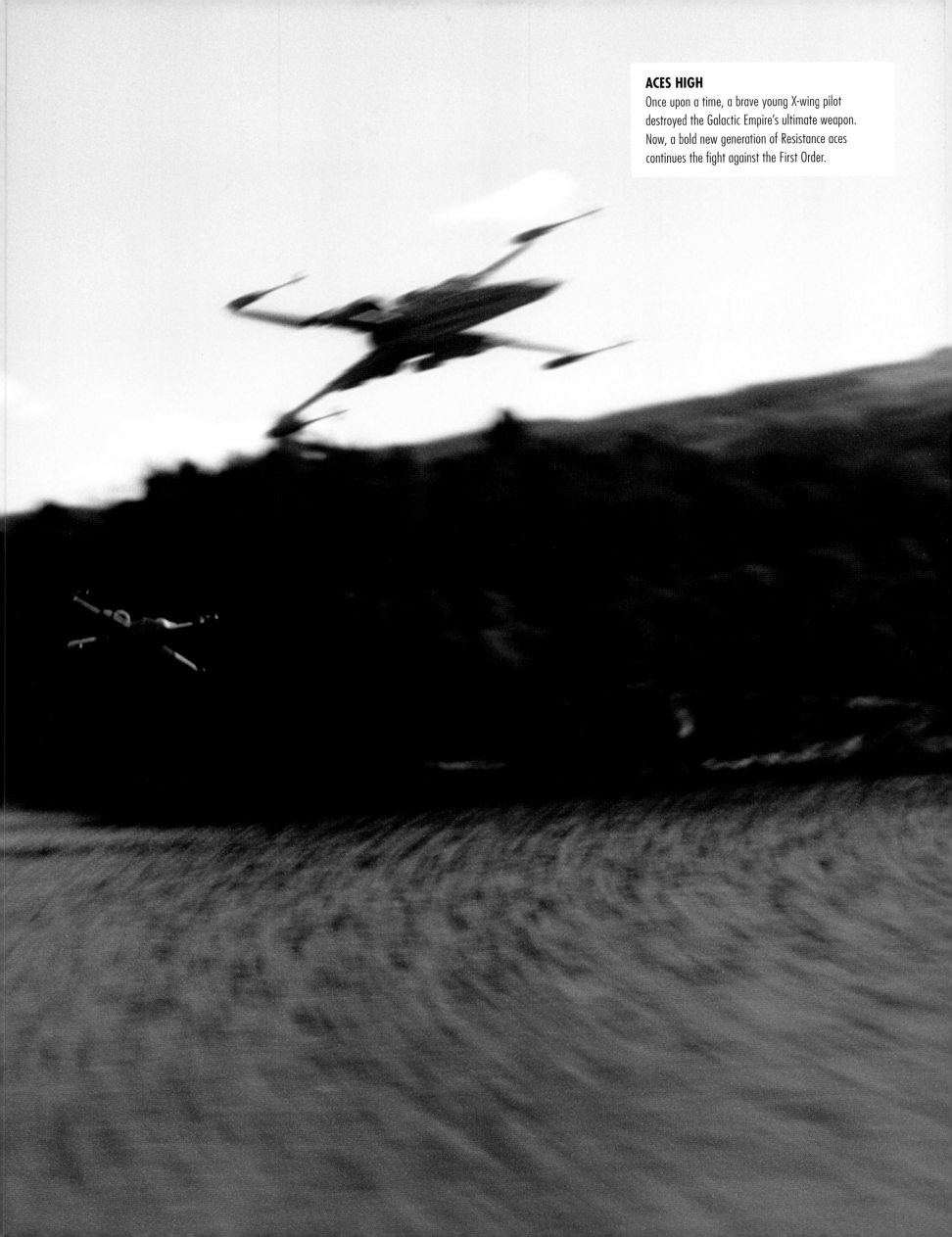

ACES HIGH
Once upon a time, a brave young X-wing pilot destroyed the Galactic Empire's ultimate weapon. Now, a bold new generation of Resistance aces continues the fight against the First Order.

COMMAND SHUTTLE

THE FIRST ORDER'S top officers and dignitaries travel in batwinged command shuttles, heavily guarded by TIE fighter escorts. Looking like dark birds of prey, command shuttles have formidable heavy laser cannons, but their biggest asset is their defensive capabilities. Advanced sensor suites in the upper wings monitor communications and scan for potential enemies long before they reach firing range, while the lower wings are lined with efficient shield projectors and powerful jammers. These technologies are the products of secret research conducted in the First Order's hidden shipyards and laboratories. One of these shuttles ferries the dark side apprentice Kylo Ren from the Star Destroyer *Finalizer* to the forlorn desert world of Jakku, in search of a secret that could allow Kylo to fulfill his destiny.

IMPERIAL SECRETS

When the Empire collapsed, the Emperor's servants fled into the Unknown Regions with some of his regime's greatest secrets. For years, military scout ships had explored far beyond the galactic frontier, surveying star systems and blazing hyperspace routes known only to a select few. Far from the prying eyes of the New Republic, the remnants of the Empire established new bases, shipyards, and weapons labs, and began plotting a return to power.

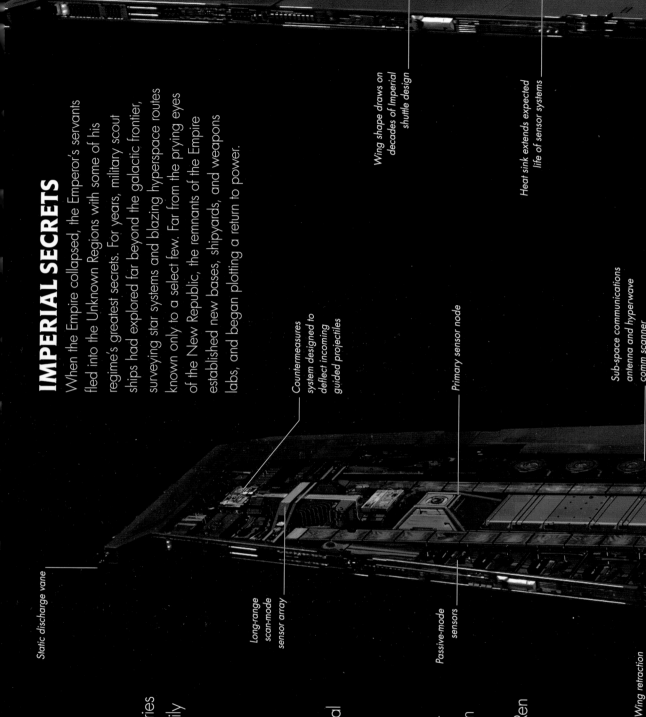

Wing shape draws on decades of Imperial shuttle design

Heat sink extends expected life of sensor systems

Jammer modulation node

Countermeasures system designed to deflect incoming guided projectiles

Primary sensor node

Sub-space communications antenna and hyperwave comm scanner

Locking mechanism holds extended wing in position

Static discharge vane

Long-range scan-mode sensor array

Passive-mode sensors

Wing retraction guide rails

Sensor jammer

DATA FILE

> **MANUFACTURER** Sienar-Jaemus Fleet Systems

> **MODEL** *Upsilon*-class shuttle

> **CLASS** Transport

> **HEIGHT** 37.2 meters (122.04 feet) with wings extended

> **CREW** 1–5 plus up to 10 passengers

> **WEAPONS** 2 twin laser cannons

> **AFFILIATION** First Order

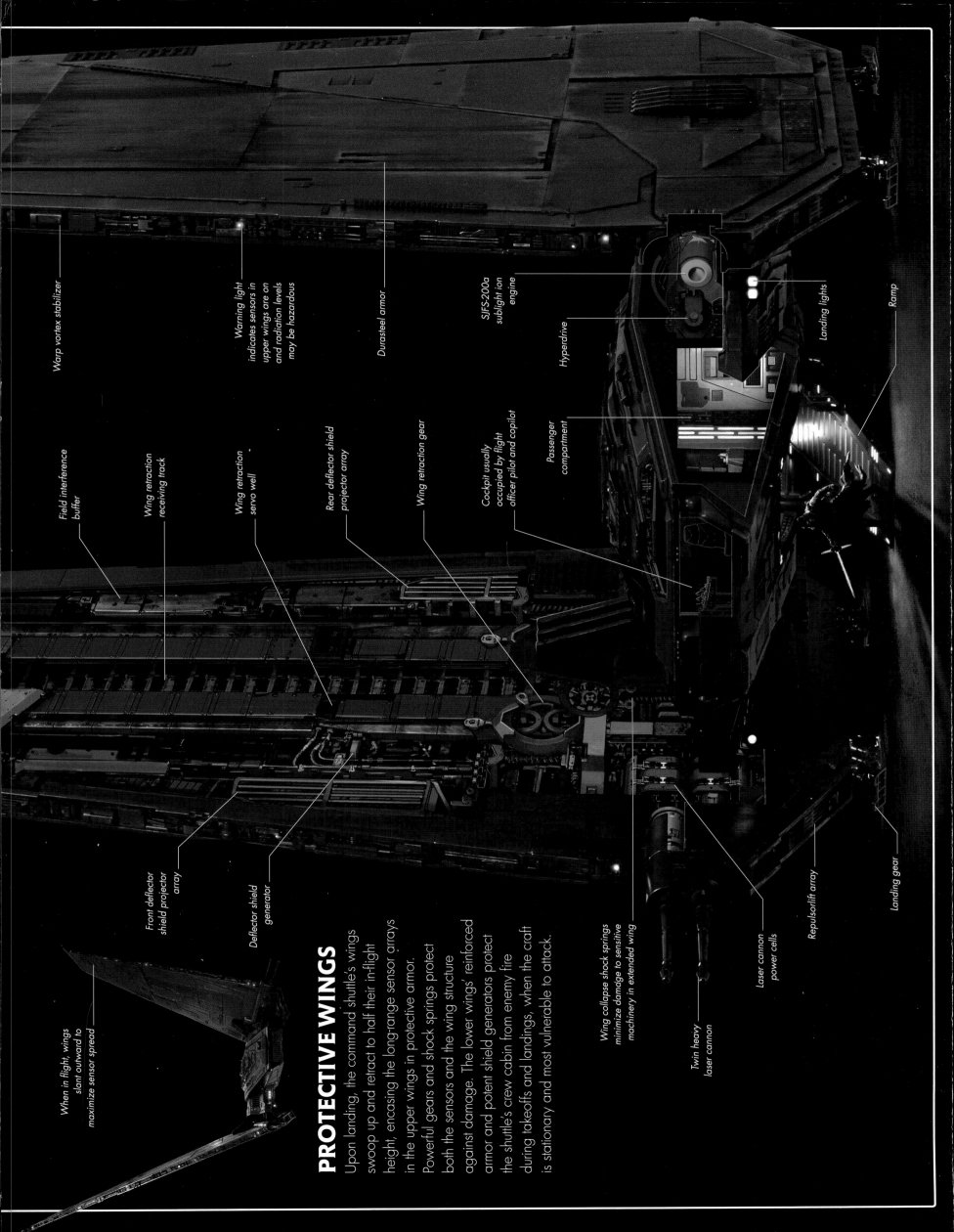

Warp vortex stabilizer

Warning light
indicates sensors in
upper wings are on
and radiation levels
may be hazardous

Durasteel armor

SJFS-200a
sublight ion
engine

Hyperdrive

Landing lights

Ramp

Field interference
buffer

Wing retraction
receiving track

Wing retraction
servo well

Rear deflector shield
projector array

Wing retraction gear

Cockpit usually
occupied by flight
officer pilot and copilot

Passenger
compartment

Front deflector
shield projector
array

Deflector shield
generator

Wing collapse shock springs
minimize damage to sensitive
machinery in extended wing

Twin heavy
laser cannon

Laser cannon
power cells

Repulsorlift array

Landing gear

PROTECTIVE WINGS

Upon landing, the command shuttle's wings
swoop up and retract to half their in-flight
height, encasing the long-range sensor arrays
in the upper wings in protective armor.
Powerful gears and shock springs protect
both the sensors and the wing structure
against damage. The lower wings' reinforced
armor and potent shield generators protect
the shuttle's crew cabin from enemy fire
during takeoffs and landings, when the craft
is stationary and most vulnerable to attack.

When in flight, wings
slant outward to
maximize sensor spread

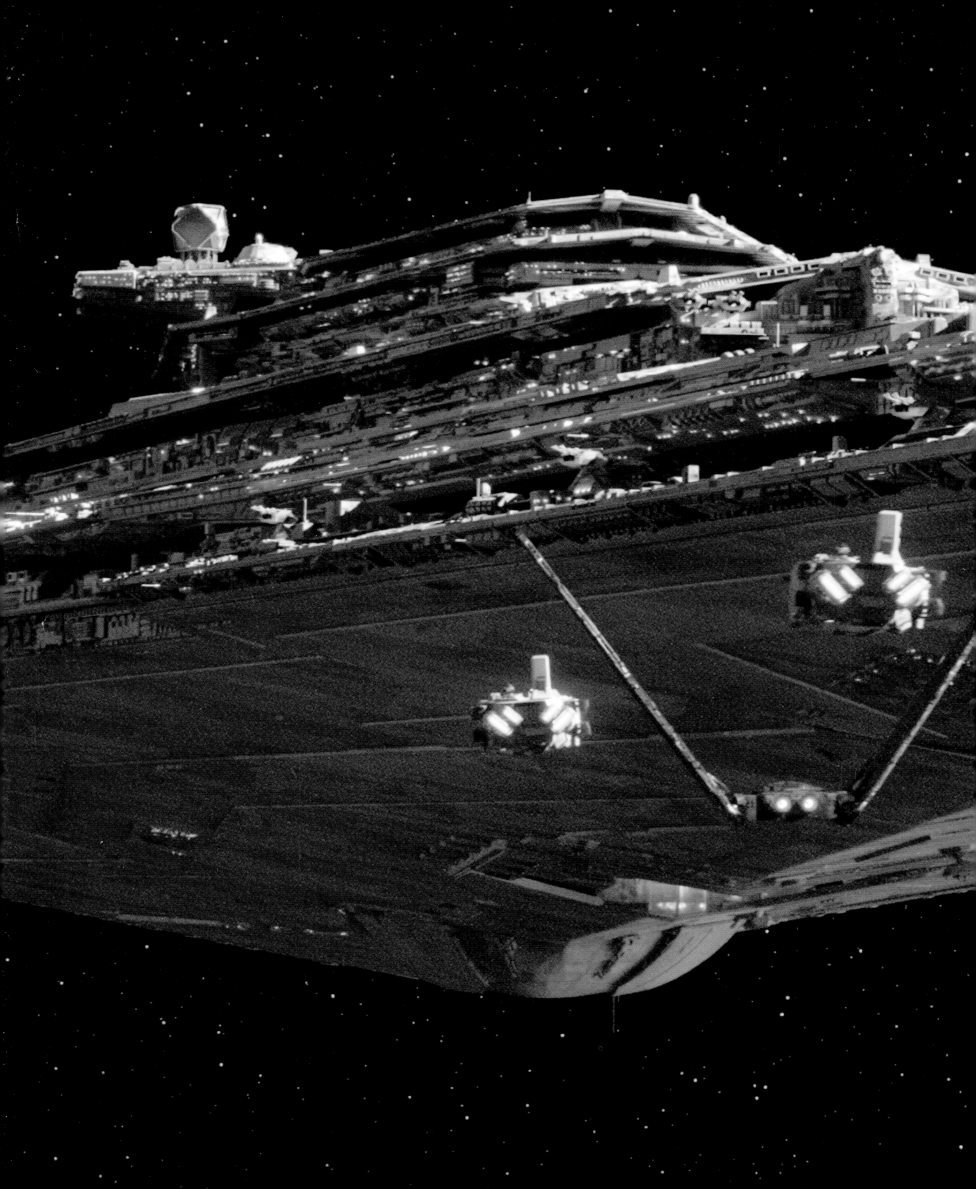

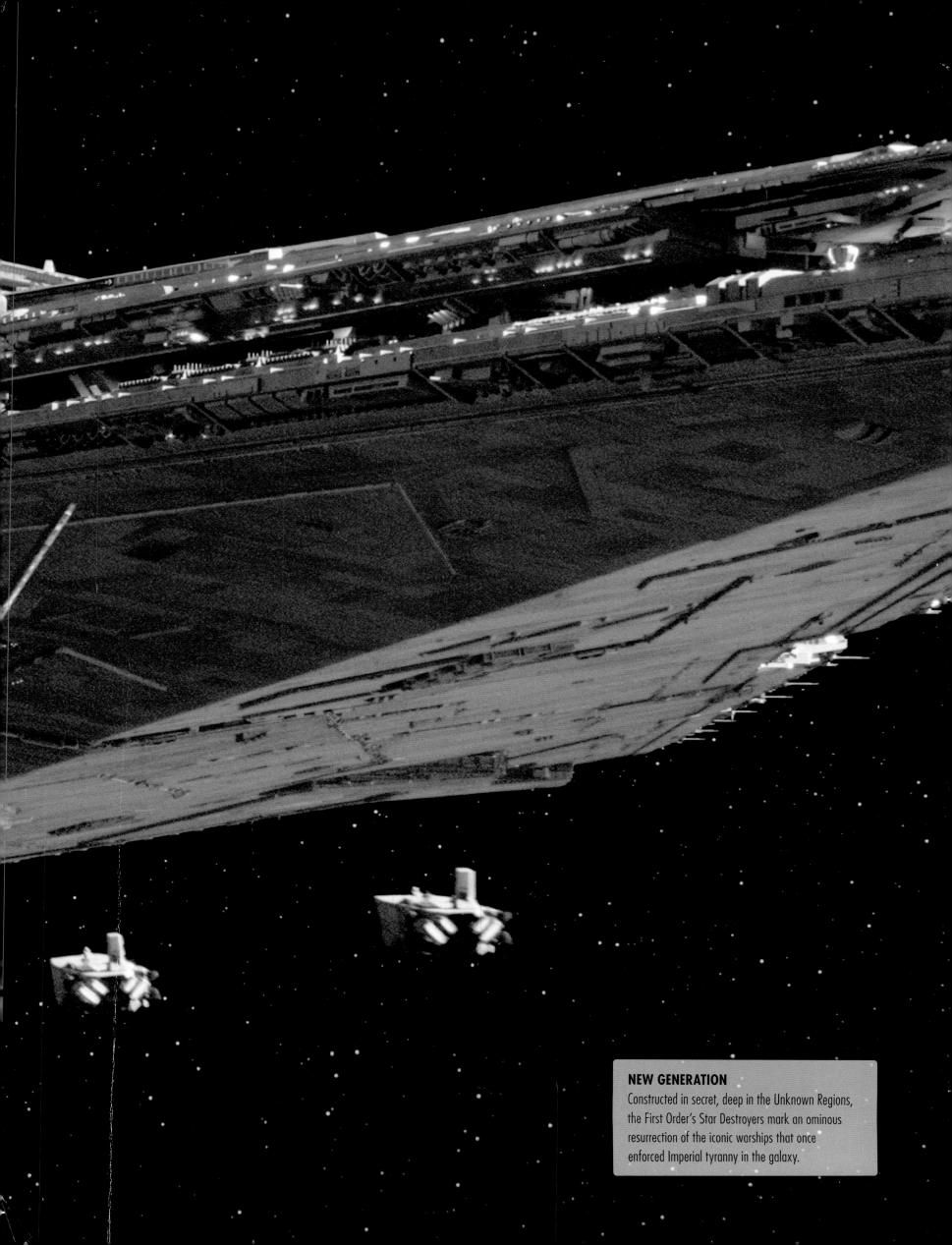

NEW GENERATION
Constructed in secret, deep in the Unknown Regions, the First Order's Star Destroyers mark an ominous resurrection of the iconic warships that once enforced Imperial tyranny in the galaxy.

REY'S SPEEDER

REY'S PRIDE AND JOY is her custom speeder, an ungainly but powerful vehicle created using parts unearthed in the junkpiles of Niima Outpost, reclaimed from the Starship Graveyard, or acquired from Teedo traders. Armed with welding torches, hydrospanners, and bonding tape, Rey built a vehicle combining aspects of a speeder and a swoop, making use of sophisticated military hardware and civilian machinery. Rey's speeder is fast and can carry heavy loads, making it ideal for scavenging trips. The top-heavy craft would be difficult for any other pilot to control, but Rey's skills as a pilot match her genius as a mechanic.

SCAVENGER SAFEGUARDS

Light-fingered scavengers are a fact of life on Jakku, and Rey knows that without her speeder she'd be even more trapped than she already is, unable to travel between the Starship Graveyard, her makeshift homestead, and Niima Outpost. Her speeder won't power up without a fingerprint scan, and she can electrify the chassis to give a powerful jolt to anyone who touches it while she's away.

HYBRID VEHICLE

At the heart of Rey's speeder are powerful twin turbojet engines reclaimed from a wrecked cargo-hauler. Rey mounted them in a stacked configuration instead of side by side, and bolted them to powered amplifier intakes from an Imperial gunship. She then customized them with racing-swoop afterburners, a modified combustion chamber, and an array of repulsorlifts taken from crashed X-wing starfighters.

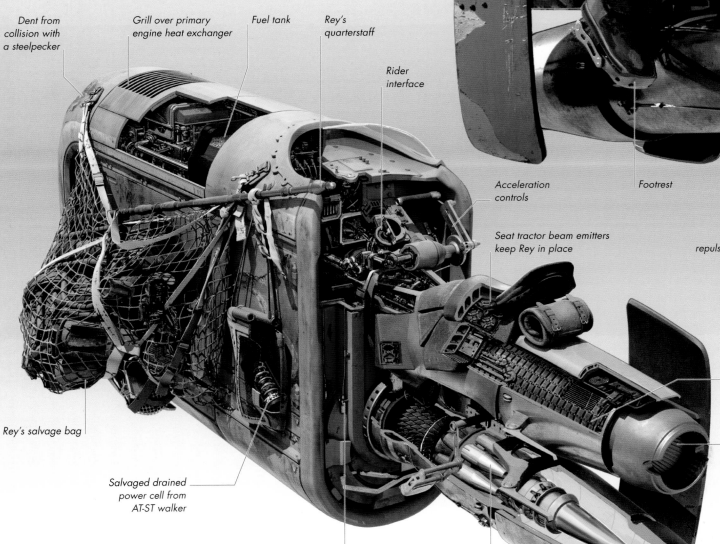

CPU housing

Rear stabilizer vane

Dent from collision with a steelpecker

Grill over primary engine heat exchanger

Fuel tank

Rey's quarterstaff

Rider interface

Acceleration controls

Footrest

Seat tractor beam emitters keep Rey in place

Rear repulsorlifts

Combustion chamber

High-density heat shielding protects rider

Rey's salvage bag

Salvaged drained power cell from AT-ST walker

Wire electrifies chassis to keep thieves away

Afterburner from crashed racing-swoop

Baffles installed to change engine pitch and keep ripper-raptors away

Exhaust cone increases thrust velocity

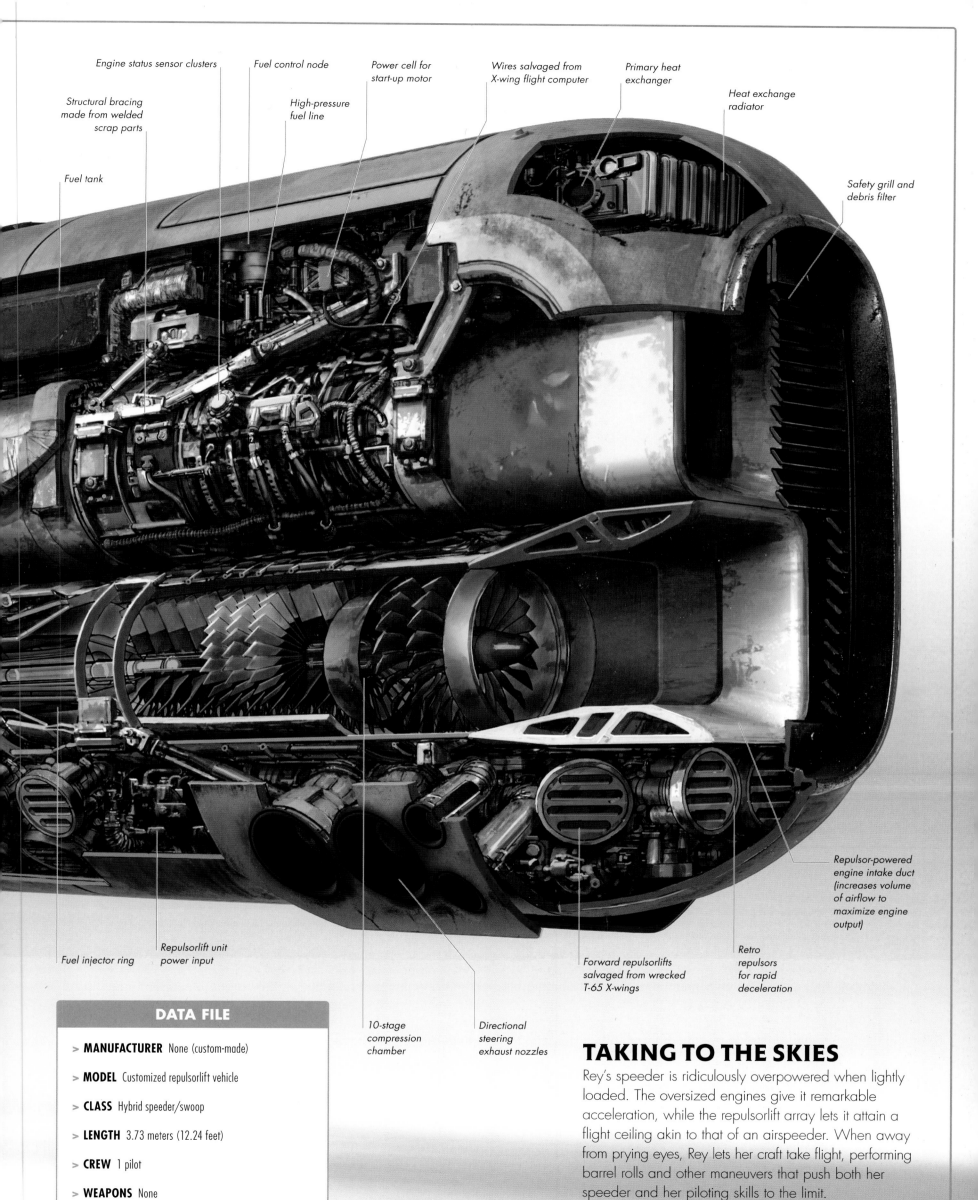

Engine status sensor clusters

Fuel control node

Power cell for start-up motor

Wires salvaged from X-wing flight computer

Primary heat exchanger

Heat exchange radiator

Structural bracing made from welded scrap parts

High-pressure fuel line

Fuel tank

Safety grill and debris filter

Fuel injector ring

Repulsorlift unit power input

10-stage compression chamber

Directional steering exhaust nozzles

Forward repulsorlifts salvaged from wrecked T-65 X-wings

Retro repulsors for rapid deceleration

Repulsor-powered engine intake duct (increases volume of airflow to maximize engine output)

DATA FILE

> **MANUFACTURER** None (custom-made)

> **MODEL** Customized repulsorlift vehicle

> **CLASS** Hybrid speeder/swoop

> **LENGTH** 3.73 meters (12.24 feet)

> **CREW** 1 pilot

> **WEAPONS** None

> **AFFILIATION** Rey

TAKING TO THE SKIES

Rey's speeder is ridiculously overpowered when lightly loaded. The oversized engines give it remarkable acceleration, while the repulsorlift array lets it attain a flight ceiling akin to that of an airspeeder. When away from prying eyes, Rey lets her craft take flight, performing barrel rolls and other maneuvers that push both her speeder and her piloting skills to the limit.

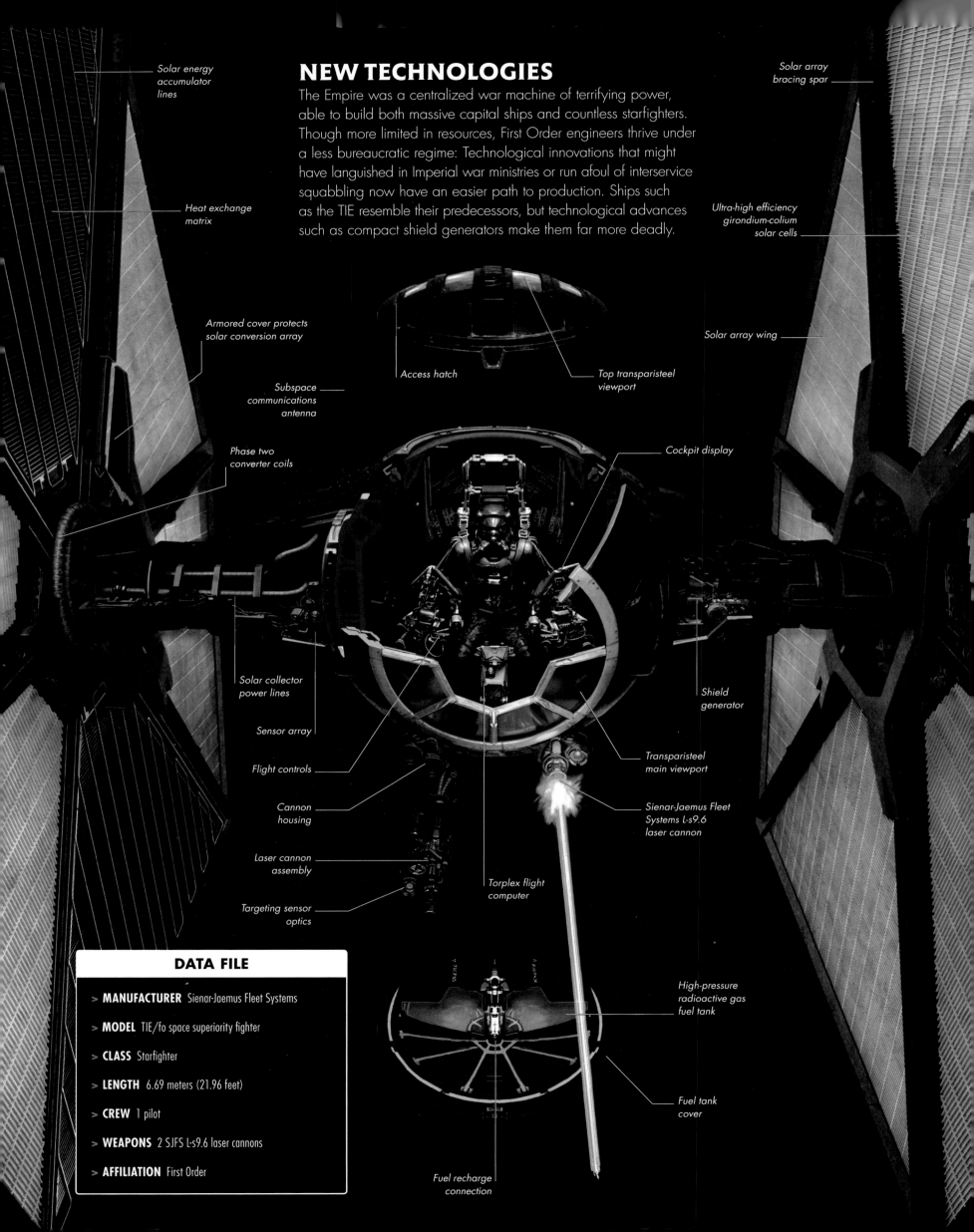

NEW TECHNOLOGIES

The Empire was a centralized war machine of terrifying power, able to build both massive capital ships and countless starfighters. Though more limited in resources, First Order engineers thrive under a less bureaucratic regime: Technological innovations that might have languished in Imperial war ministries or run afoul of interservice squabbling now have an easier path to production. Ships such as the TIE resemble their predecessors, but technological advances such as compact shield generators make them far more deadly.

Solar energy
accumulator
lines

Heat exchange
matrix

Solar array
bracing spar

Ultra-high efficiency
girondium-colium
solar cells

Armored cover protects
solar conversion array

Solar array wing

Subspace
communications
antenna

Access hatch

Top transparisteel
viewport

Phase two
converter coils

Cockpit display

Solar collector
power lines

Shield
generator

Sensor array

Flight controls

Transparisteel
main viewport

Cannon
housing

Sienar-Jaemus Fleet
Systems L-s9.6
laser cannon

Laser cannon
assembly

Torplex flight
computer

Targeting sensor
optics

High-pressure
radioactive gas
fuel tank

Fuel tank
cover

Fuel recharge
connection

DATA FILE

> **MANUFACTURER** Sienar-Jaemus Fleet Systems

> **MODEL** TIE/fo space superiority fighter

> **CLASS** Starfighter

> **LENGTH** 6.69 meters (21.96 feet)

> **CREW** 1 pilot

> **WEAPONS** 2 SJFS L-s9.6 laser cannons

> **AFFILIATION** First Order

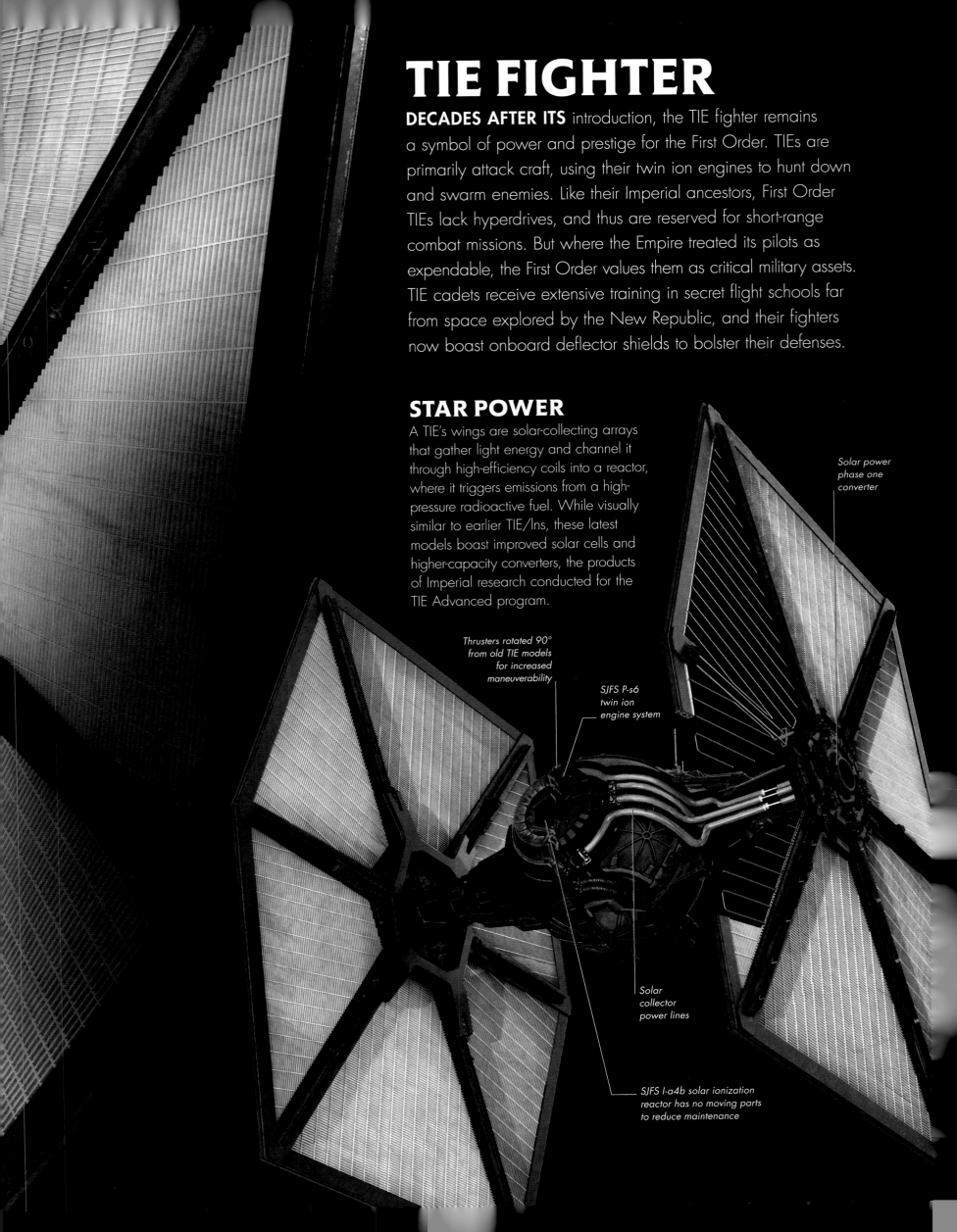

TIE FIGHTER

DECADES AFTER ITS introduction, the TIE fighter remains a symbol of power and prestige for the First Order. TIEs are primarily attack craft, using their twin ion engines to hunt down and swarm enemies. Like their Imperial ancestors, First Order TIEs lack hyperdrives, and thus are reserved for short-range combat missions. But where the Empire treated its pilots as expendable, the First Order values them as critical military assets. TIE cadets receive extensive training in secret flight schools far from space explored by the New Republic, and their fighters now boast onboard deflector shields to bolster their defenses.

STAR POWER

A TIE's wings are solar-collecting arrays that gather light energy and channel it through high-efficiency coils into a reactor, where it triggers emissions from a high-pressure radioactive fuel. While visually similar to earlier TIE/lns, these latest models boast improved solar cells and higher-capacity converters, the products of Imperial research conducted for the TIE Advanced program.

Solar power phase one converter

Thrusters rotated 90° from old TIE models for increased maneuverability

SJFS P-s6 twin ion engine system

Solar collector power lines

SJFS I-a4b solar ionization reactor has no moving parts to reduce maintenance

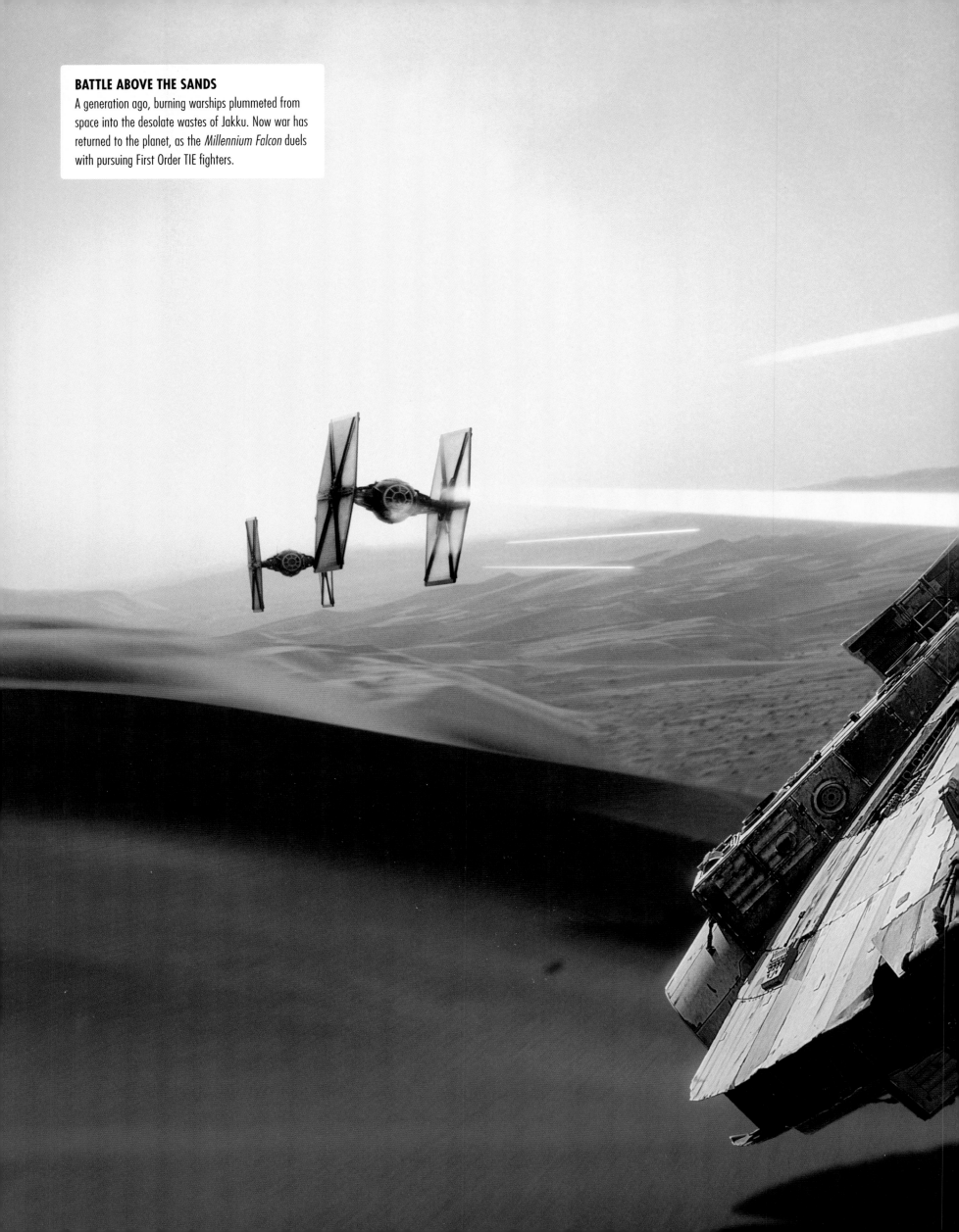

BATTLE ABOVE THE SANDS

A generation ago, burning warships plummeted from space into the desolate wastes of Jakku. Now war has returned to the planet, as the *Millennium Falcon* duels with pursuing First Order TIE fighters.

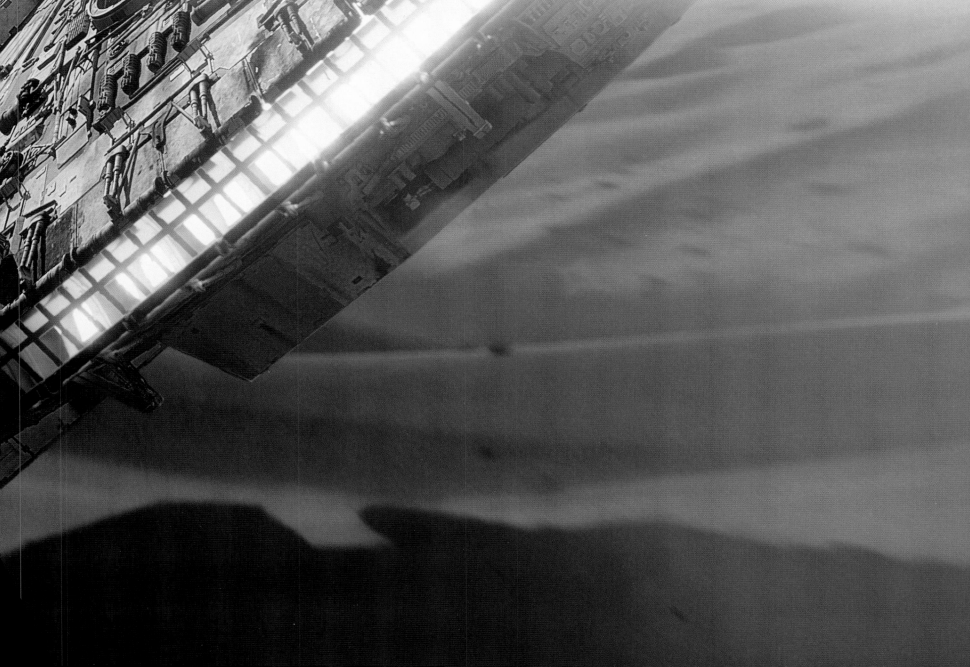

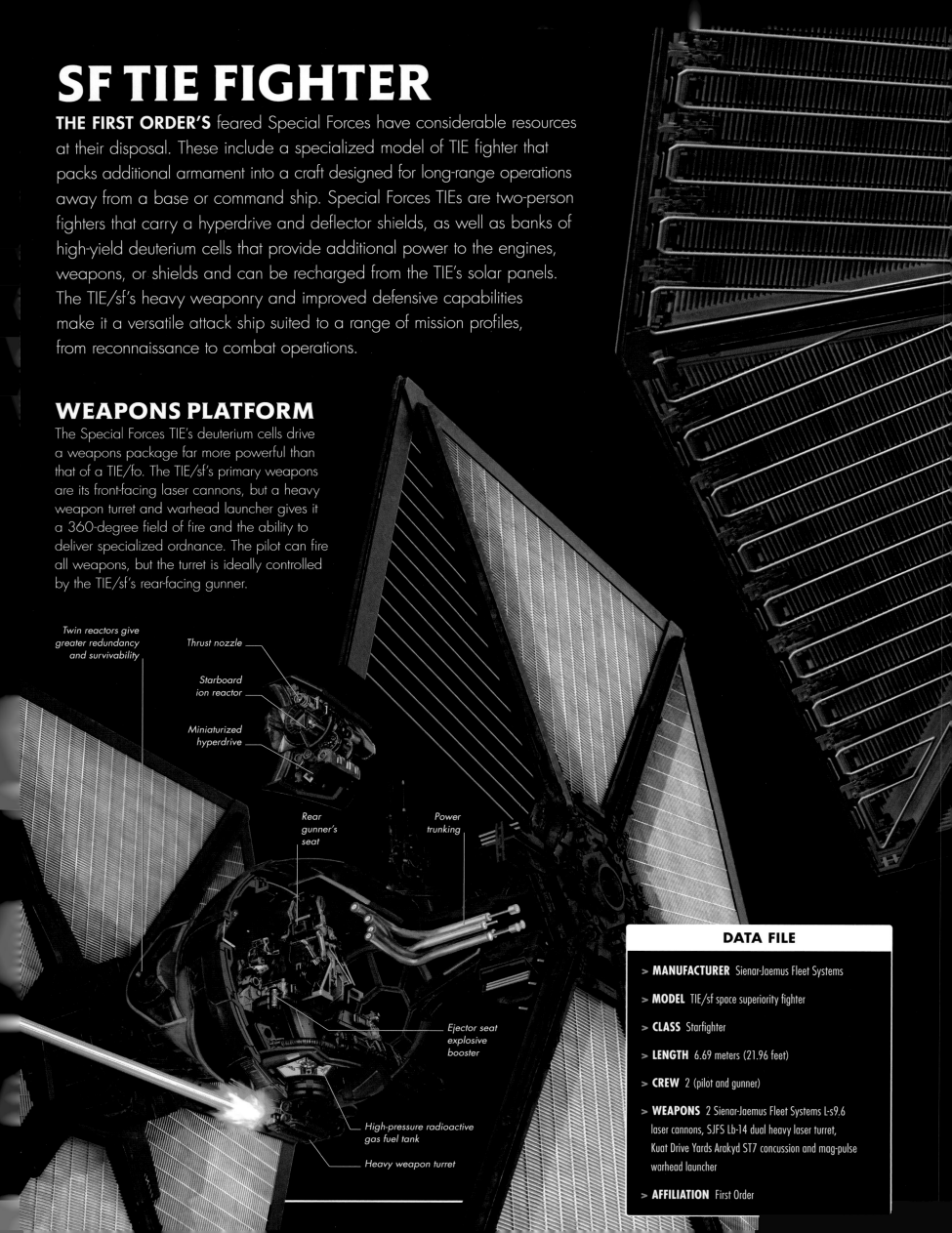

SF TIE FIGHTER

THE FIRST ORDER'S feared Special Forces have considerable resources at their disposal. These include a specialized model of TIE fighter that packs additional armament into a craft designed for long-range operations away from a base or command ship. Special Forces TIEs are two-person fighters that carry a hyperdrive and deflector shields, as well as banks of high-yield deuterium cells that provide additional power to the engines, weapons, or shields and can be recharged from the TIE's solar panels. The TIE/sf's heavy weaponry and improved defensive capabilities make it a versatile attack ship suited to a range of mission profiles, from reconnaissance to combat operations.

WEAPONS PLATFORM

The Special Forces TIE's deuterium cells drive a weapons package far more powerful than that of a TIE/fo. The TIE/sf's primary weapons are its front-facing laser cannons, but a heavy weapon turret and warhead launcher gives it a 360-degree field of fire and the ability to deliver specialized ordnance. The pilot can fire all weapons, but the turret is ideally controlled by the TIE/sf's rear-facing gunner.

Twin reactors give greater redundancy and survivability

Thrust nozzle

Starboard ion reactor

Miniaturized hyperdrive

Rear gunner's seat

Power trunking

Ejector seat explosive booster

High-pressure radioactive gas fuel tank

Heavy weapon turret

DATA FILE

> **MANUFACTURER** Sienar-Jaemus Fleet Systems

> **MODEL** TIE/sf space superiority fighter

> **CLASS** Starfighter

> **LENGTH** 6.69 meters (21.96 feet)

> **CREW** 2 (pilot and gunner)

> **WEAPONS** 2 Sienar-Jaemus Fleet Systems L-s9.6 laser cannons, SJFS Lb-14 dual heavy laser turret, Kuat Drive Yards Arakyd ST7 concussion and mag-pulse warhead launcher

> **AFFILIATION** First Order

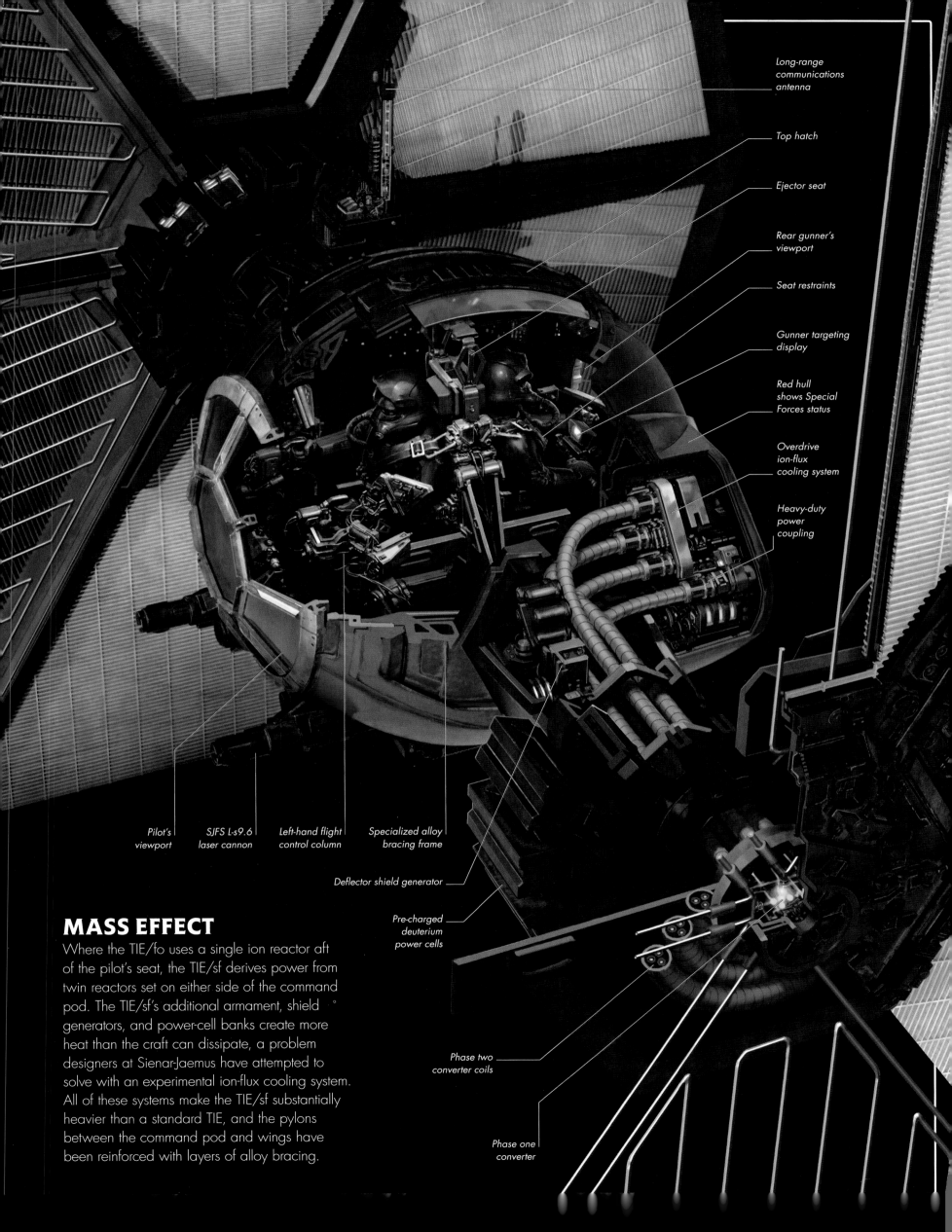

Long-range
communications
antenna

Top hatch

Ejector seat

Rear gunner's
viewport

Seat restraints

Gunner targeting
display

Red hull
shows Special
Forces status

Overdrive
ion-flux
cooling system

Heavy-duty
power
coupling

Pilot's
viewport

SJFS L-s9.6
laser cannon

Left-hand flight
control column

Specialized alloy
bracing frame

Deflector shield generator

Pre-charged
deuterium
power cells

Phase two
converter coils

Phase one
converter

MASS EFFECT

Where the TIE/fo uses a single ion reactor aft
of the pilot's seat, the TIE/sf derives power from
twin reactors set on either side of the command
pod. The TIE/sf's additional armament, shield
generators, and power-cell banks create more
heat than the craft can dissipate, a problem
designers at Sienar-Jaemus have attempted to
solve with an experimental ion-flux cooling system.
All of these systems make the TIE/sf substantially
heavier than a standard TIE, and the pylons
between the command pod and wings have
been reinforced with layers of alloy bracing.

QUADJUMPER

ORBITAL TRANSFER YARDS are busy places, where every second spent moving a freight container means credits lost from a shipping firm's bottom line. Quadjumpers attach magnetic clamps to the undersides of cargo containers, then use their quartet of massive thrusters to shove and yank the containers wherever the yard boss needs them to be. The quadjumper's bow cockpit is almost entirely viewports, giving the pilot maximum visibility amid the chaos of port. The other seats are typically reserved for relief pilots, engineers, or port officials.

A TUGGER'S LIFE

Captains of bulk freighters boast of flying from one side of the galaxy to the other, but most are helpless when it comes to seeing cargo across the final few kilometers between their hulls and their customers' hands. That job falls to spacetug pilots, and depends on their skill with throttles, control yokes, and tractor-beam emitters. Spacetug pilots are noticed only when they're in the way, and take perverse pride in that fact.

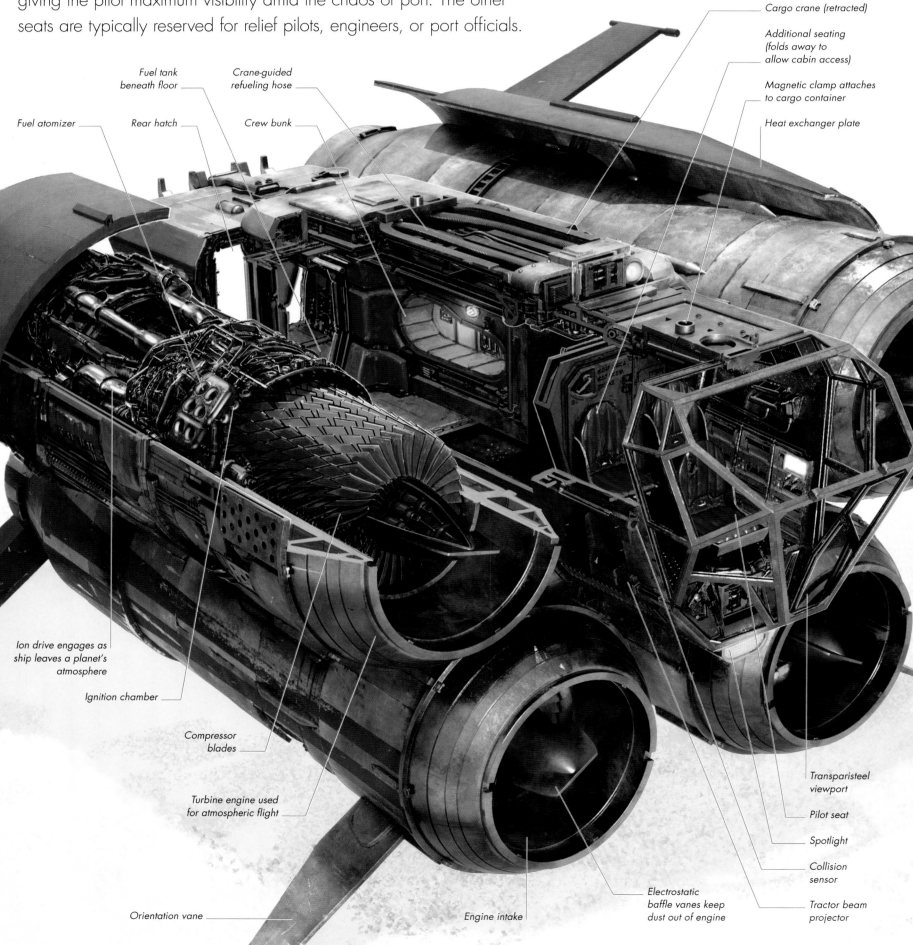

Cargo crane (retracted)

Additional seating (folds away to allow cabin access)

Magnetic clamp attaches to cargo container

Heat exchanger plate

Fuel tank beneath floor

Crane-guided refueling hose

Fuel atomizer

Rear hatch

Crew bunk

Ion drive engages as ship leaves a planet's atmosphere

Ignition chamber

Compressor blades

Turbine engine used for atmospheric flight

Orientation vane

Engine intake

Electrostatic baffle vanes keep dust out of engine

Transparisteel viewport

Pilot seat

Spotlight

Collision sensor

Tractor beam projector

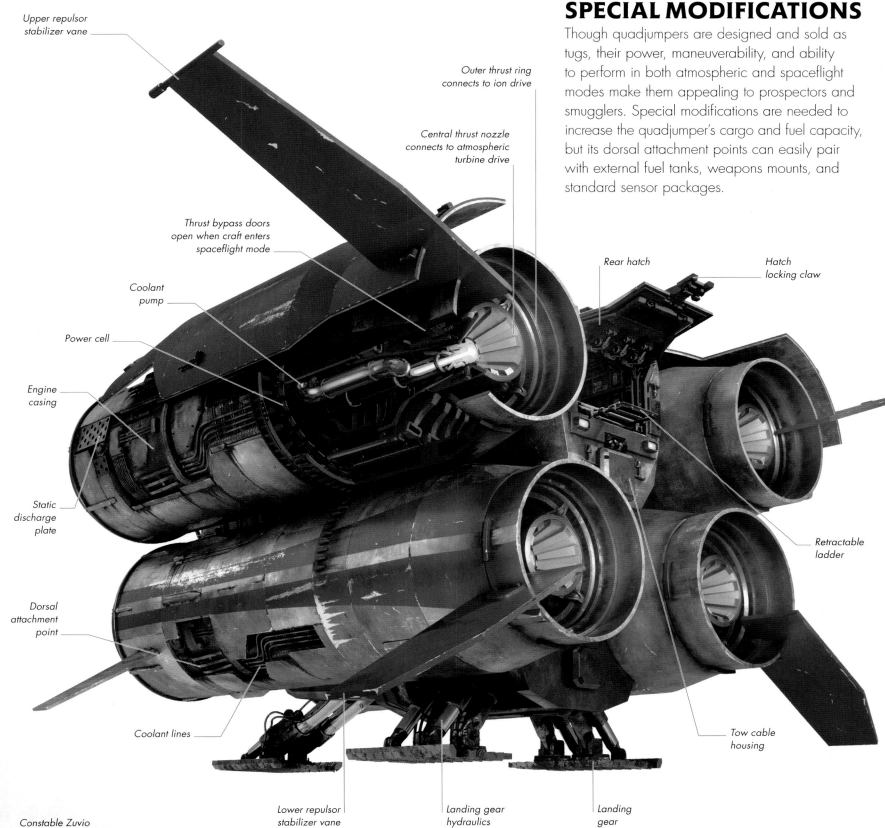

Upper repulsor
stabilizer vane

Outer thrust ring
connects to ion drive

Central thrust nozzle
connects to atmospheric
turbine drive

Thrust bypass doors
open when craft enters
spaceflight mode

Coolant
pump

Power cell

Engine
casing

Static
discharge
plate

Dorsal
attachment
point

Coolant lines

Rear hatch

Hatch
locking claw

Retractable
ladder

Tow cable
housing

Lower repulsor
stabilizer vane

Landing gear
hydraulics

Landing
gear

SPECIAL MODIFICATIONS

Though quadjumpers are designed and sold as
tugs, their power, maneuverability, and ability
to perform in both atmospheric and spaceflight
modes make them appealing to prospectors and
smugglers. Special modifications are needed to
increase the quadjumper's cargo and fuel capacity,
but its dorsal attachment points can easily pair
with external fuel tanks, weapons mounts, and
standard sensor packages.

Constable Zuvio
of the Niima
Outpost Militia

Unkar Plutt

BIG PLANS?

Jakku is light-years from the nearest transfer yard—
the Empire's orbital facilities were reserved for
military use, and blasted into scrap decades ago.
So what is an unmodified quadjumper doing out
on the edge of the Unknown Regions? Junk dealer
Unkar Plutt is planning to buy it from a team of junk
haulers who moonlight as arms dealers, and talks
vaguely of how credits will roll in once his plans
for the craft are set in motion. In the meantime,
the quadjumper sits in Niima's Outpost's Bay 3,
next to the freighter Unkar keeps beneath a tarp.

DATA FILE
> **MANUFACTURER** Subpro
> **MODEL** Quadrijet transfer spacetug
> **CLASS** Spacetug
> **LENGTH** 7.98 meters (26.18 feet)
> **CREW** 1 pilot, plus up to 2 passengers
> **WEAPONS** None
> **AFFILIATION** For sale

MILLENNIUM FALCON

ONCE FAMOUS AS one of the galaxy's fastest starships, the *Millennium Falcon* has fallen on hard times, languishing beneath a tarp in Jakku's dilapidated spaceport. Unkar Plutt won't say how he acquired the battered freighter and has refused to let Niima Outpost's scavengers strip her of useful components, insisting that the *Falcon* can still fly and that he has big plans for her. Beneath her shabby exterior, the old smuggler ship remains full of surprises: Her sublight engines are heavily modified for additional speed, her customized hyperdrive is twice the size of a stock YT-1300's, and her shields and weapons are more suited for a much larger warship.

NEW PARTS

The *Falcon*'s military-grade rectenna snapped off during the Battle of Endor and has been replaced with a civilian model Corellian Engineering Corporation sensor dish, degrading the freighter's ability to detect and target hostile ships.

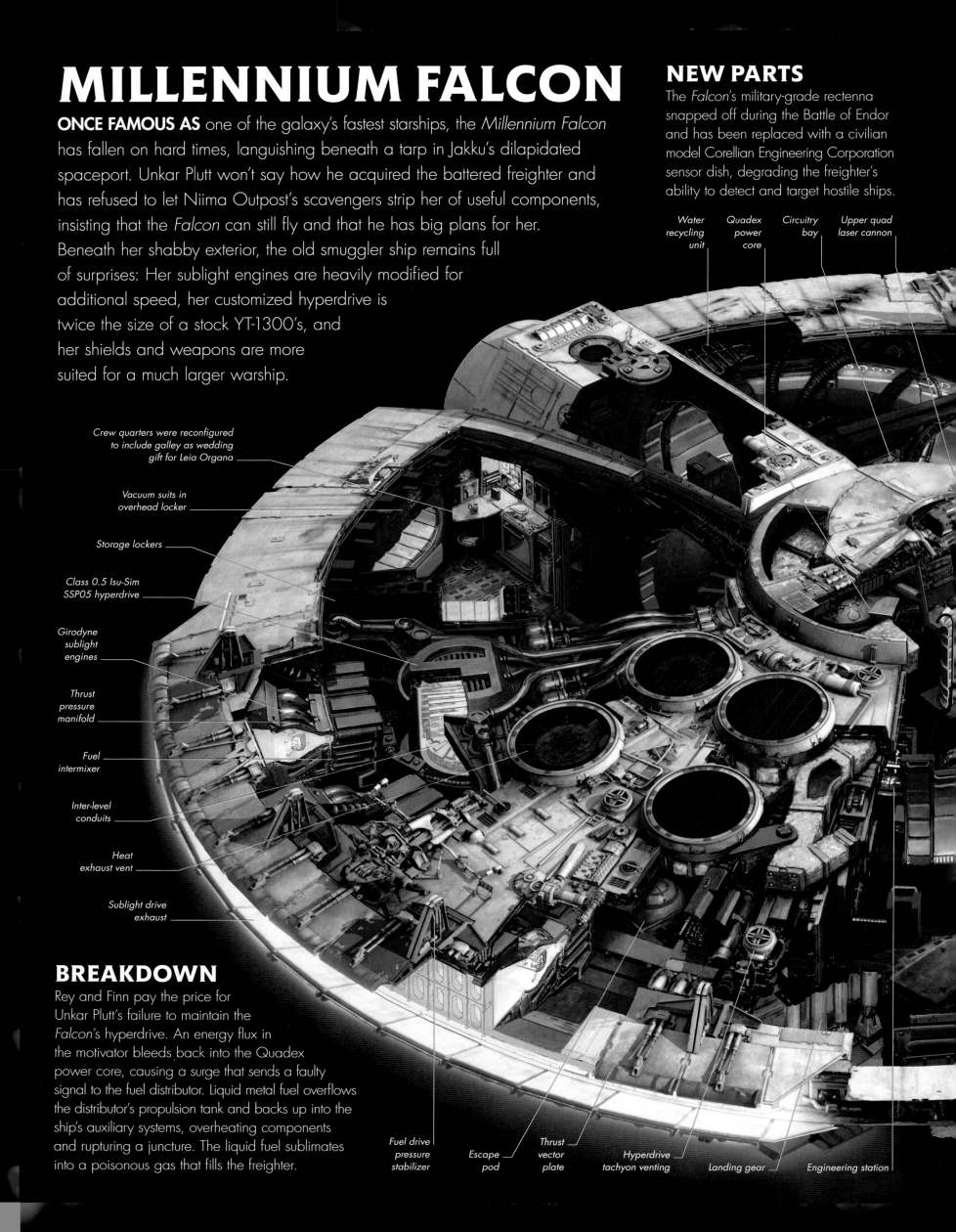

Water recycling unit

Quadex power core

Circuitry bay

Upper quad laser cannon

Crew quarters were reconfigured to include galley as wedding gift for Leia Organa

Vacuum suits in overhead locker

Storage lockers

Class 0.5 Isu-Sim SSP05 hyperdrive

Girodyne sublight engines

Thrust pressure manifold

Fuel intermixer

Inter-level conduits

Heat exhaust vent

Sublight drive exhaust

Fuel drive pressure stabilizer

Escape pod

Thrust vector plate

Hyperdrive tachyon venting

Landing gear

Engineering station

BREAKDOWN

Rey and Finn pay the price for Unkar Plutt's failure to maintain the *Falcon*'s hyperdrive. An energy flux in the motivator bleeds back into the Quadex power core, causing a surge that sends a faulty signal to the fuel distributor. Liquid metal fuel overflows the distributor's propulsion tank and backs up into the ship's auxiliary systems, overheating components and rupturing a juncture. The liquid fuel sublimates into a poisonous gas that fills the freighter.

The *Falcon*'s side-mounted cockpit and front-facing mandibles recall her origins as an intermodal tug pushing containers in orbital freight yards. But as with many YT-1300s, an enterprising captain saw that her powerful engines and modular construction made her ideal for carrying cargoes of dubious legality.

Replacement sensor rectenna

Relief pilot bunk added by Vanver and Toursant Irving

Concealed entry point for freight loading area

Gunrunner Gannis Ducain refurbished gun well with custom rotating core

Upgraded Chedak subspace radio

Communal space with dejarik table

Forward freight elevator

Freight loading doors

Outdated Imperial IFF transponder

Tractor beam projector

Concussion missile

Passive sensor antenna

Landing jet

Forward (#2) cargo hold

Shield generator

Life support systems

Hyperdrive initiation lever

Cockpit access tunnel

Hydraulic system

Starboard-side airlock

Power converter

Rear (#3) cargo hold

Boarding ramp

DATA FILE

> **MANUFACTURER** Corellian Engineering Corporation

> **MODEL** Corellian YT-1300f light freighter (modified)

> **CLASS** Transport

> **LENGTH** 34.52 meters (113.25 feet)

> **CREW** 2 (minimum)

> **WEAPONS** 2 CEC AG-2G quad laser cannons, 2 Arakyd ST2 concussion missile tubes, 1 BlasTech Ax-108 "Ground Buzzer" blaster cannon

> **AFFILIATION** Unkar Plutt

HAN'S FREIGHTER

THE GALAXY REMEMBERS Han Solo and Chewbacca as the daredevil pilots of the *Millennium Falcon*, equally legendary as smugglers and rebel heroes. But that was a long time ago. The *Falcon* is gone, and has eluded every attempt by her former owners to track her down. Han and Chewie now operate the *Eravana*, a massive bulk freighter that handles like a concussed bantha. The Corellian and the Wookiee have made a fair amount of credits with their new ship, criss-crossing the galaxy carrying everything from bulk consumables needed by remote colonies to exotic fauna desired by wealthy collectors. They have also made more than a few enemies—the inevitable consequence of Han's dubious business practices.

MOVING CARGO
Bulk freighters such as the *Baleen*-class move huge amounts of cargo across the galaxy every day, and are essential to commerce. Built in orbital shipyards, they almost never enter a planet's atmosphere, docking instead at space stations and transfer yards to load and unload cargo. Most bulk freighters are owned by corporations, as few independent captains have the credits to acquire and maintain these giant craft.

Primary heat exchanger and cooling vent

Docking bay repressurization system

Observation deck

Docking bay door

Door locking mechanism

Force field projectors

Spotlights

Maneuvering thrusters

Heavy-duty latches for docking bay door

Recently recovered Millennium Falcon

Forward sensor array

Tractor beam projectors

Han's cabin

Long-range communications antenna

DATA FILE

> **MANUFACTURER** Corellian Engineering Corporation

> **MODEL** *Baleen*-class heavy freighter

> **CLASS** Bulk freighter

> **LENGTH** 425.99 meters (1397.59 feet)

> **CREW** 2 minimum, 6 recommended

> **WEAPONS** None

> **AFFILIATION** Han Solo and Chewbacca

FLYING LABYRINTH
The *Falcon* felt like home, but the *Eravana* is a means to an end, with Han and Chewie monitoring the giant ship's cargos and keeping her plodding along her course. The freighter's forward hold doubles as a docking bay, and is used for cargo that demands special handling. Everything else is housed in containers attached to the transport grid between the bow section and engines—a sprawling labyrinth of goods bound for distant starports.

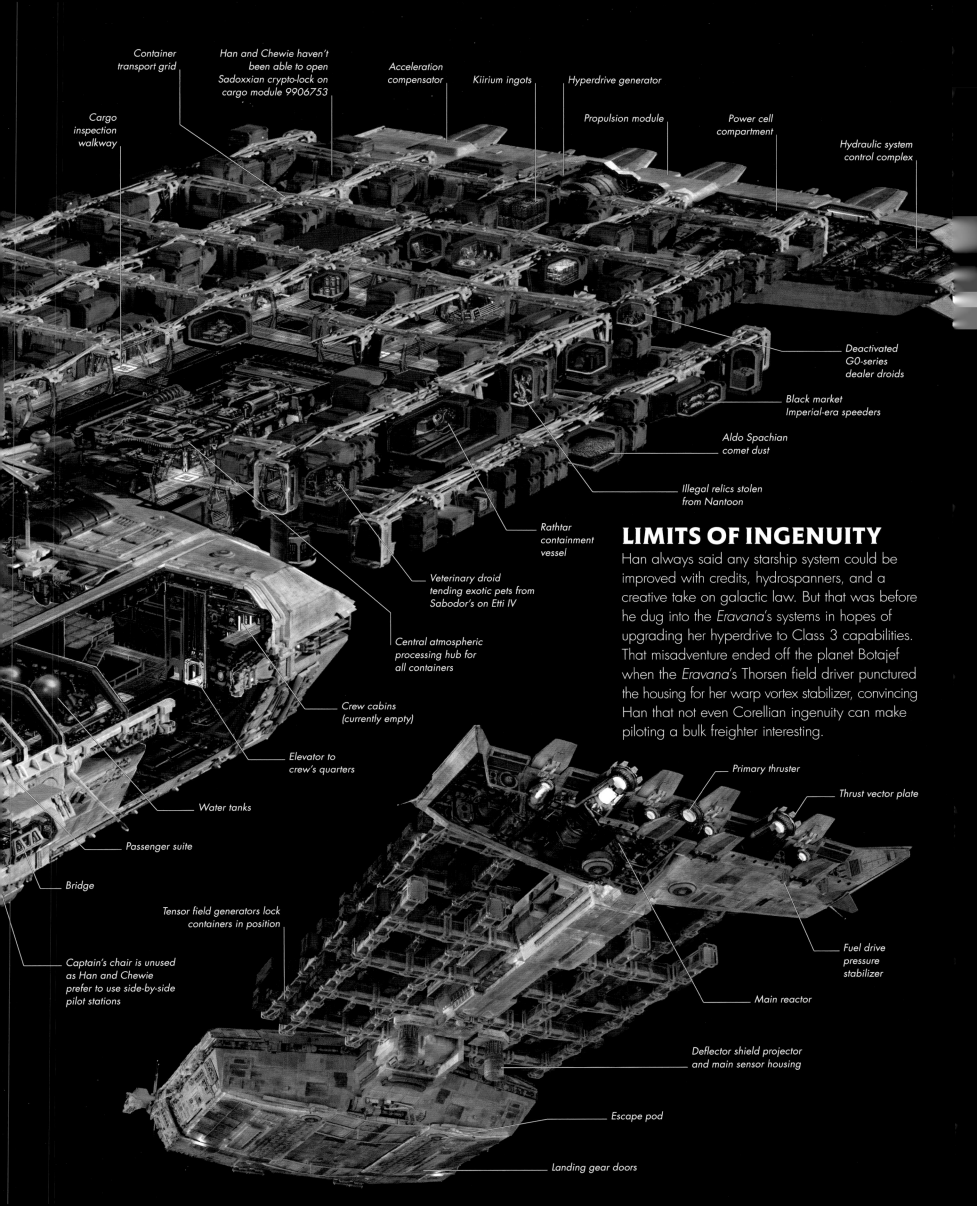

Container transport grid

Han and Chewie haven't been able to open Sadoxxian crypto-lock on cargo module 9906753

Acceleration compensator

Kiirium ingots

Hyperdrive generator

Propulsion module

Power cell compartment

Hydraulic system control complex

Cargo inspection walkway

Deactivated G0-series dealer droids

Black market Imperial-era speeders

Aldo Spachian comet dust

Illegal relics stolen from Nantoon

Rathtar containment vessel

Veterinary droid tending exotic pets from Sabodor's on Etti IV

Central atmospheric processing hub for all containers

Crew cabins (currently empty)

Elevator to crew's quarters

Water tanks

Passenger suite

Bridge

Captain's chair is unused as Han and Chewie prefer to use side-by-side pilot stations

Tensor field generators lock containers in position

LIMITS OF INGENUITY

Han always said any starship system could be improved with credits, hydrospanners, and a creative take on galactic law. But that was before he dug into the *Eravana*'s systems in hopes of upgrading her hyperdrive to Class 3 capabilities. That misadventure ended off the planet Botajef when the *Eravana*'s Thorsen field driver punctured the housing for her warp vortex stabilizer, convincing Han that not even Corellian ingenuity can make piloting a bulk freighter interesting.

Primary thruster

Thrust vector plate

Fuel drive pressure stabilizer

Main reactor

Deflector shield projector and main sensor housing

Escape pod

Landing gear doors

HEROES OLD AND NEW
Reunited with their beloved *Millennium Falcon*, Han Solo and Chewbacca find new perils await them, born of a painful past. But new heroes have joined the fight against the forces that threaten the galaxy.

RESISTANCE TRANSPORT

THE ODD APPEARANCE of the Resistance's transports reflects their unorthodox origins and construction. The craft have been cobbled together by Resistance technicians from a hodgepodge of systems bought, begged, and stolen. Parts scrounged from scrapped B-wing Mark II's have been fitted to engine pods from Republic-era shuttles, attached to civilian passenger modules and augmented with knockoffs of hyperdrives created for the First Order. Techs bemoan frequent breakdowns but keep these ungainly craft flying, knowing they may be needed at a moment's notice.

CIVILIAN COMPARTMENTS

Resistance transport passengers ride inside two modular compartments connected and encased within a shell of surplus hull plating. Such compartments are commonly found in a variety of configurations aboard freighters and cut-rate starliners catering to travelers on a tight budget. Resistance troops and commanders alike share space with gear lockers and astromech droids, enduring the rough ride with whatever good humor they can muster.

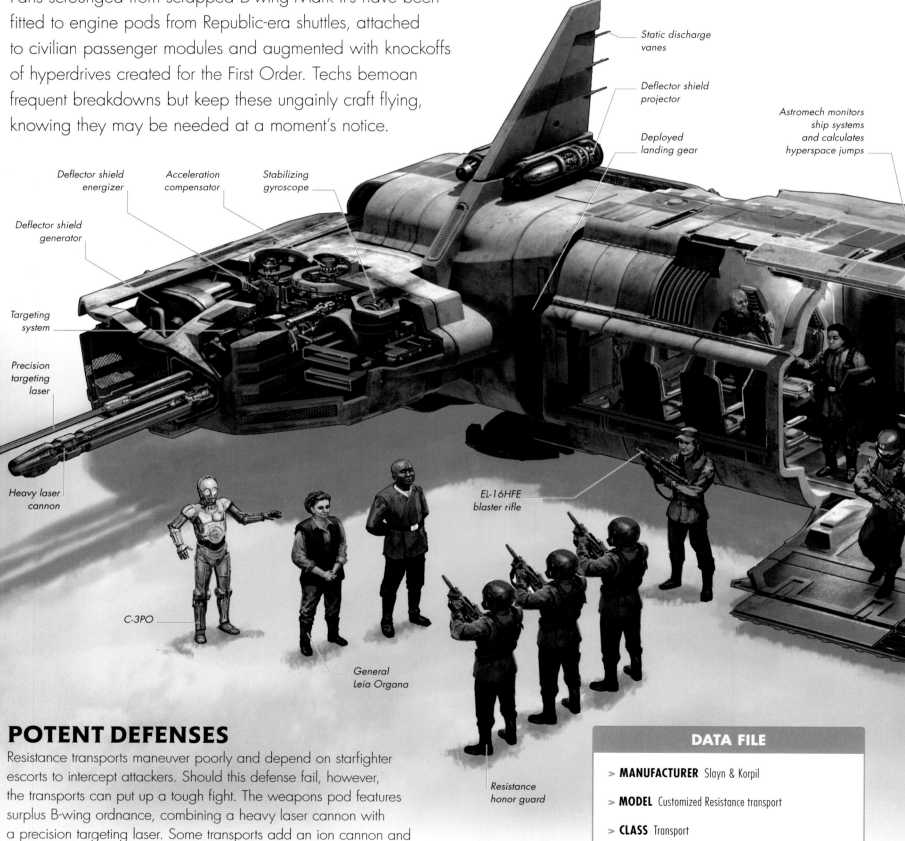

Static discharge vanes

Deflector shield projector

Deployed landing gear

Astromech monitors ship systems and calculates hyperspace jumps

Deflector shield energizer

Acceleration compensator

Stabilizing gyroscope

Deflector shield generator

Targeting system

Precision targeting laser

Heavy laser cannon

EL-16HFE blaster rifle

C-3PO

General Leia Organa

Resistance honor guard

POTENT DEFENSES

Resistance transports maneuver poorly and depend on starfighter escorts to intercept attackers. Should this defense fail, however, the transports can put up a tough fight. The weapons pod features surplus B-wing ordnance, combining a heavy laser cannon with a precision targeting laser. Some transports add an ion cannon and proton torpedo launcher to this pod, and a mount beneath the cockpit can accommodate two auto-blasters. Deflector shield projectors removed from B-wing nacelles protect the cockpit and weapons pod, with their overlapping fields shielding the passenger compartments.

DATA FILE

> **MANUFACTURER** Slayn & Korpil

> **MODEL** Customized Resistance transport

> **CLASS** Transport

> **WIDTH** 16.18 meters (53.08 feet)

> **CREW** 1 pilot plus up to 20 passengers

> **WEAPONS** 1 Gyrhil R-9X heavy laser cannon (standard)

> **AFFILIATION** Resistance

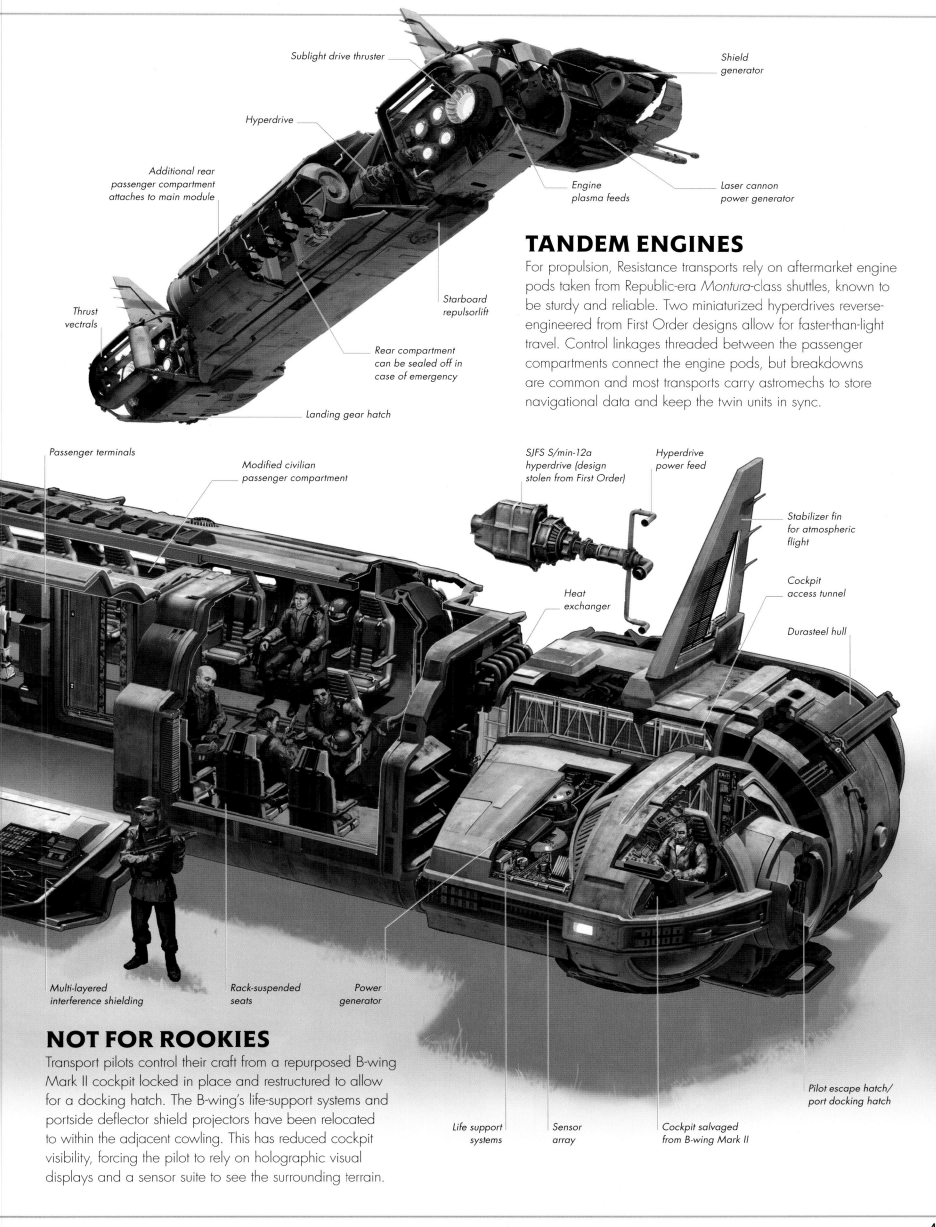

Sublight drive thruster

Hyperdrive

Additional rear
passenger compartment
attaches to main module

Shield
generator

Engine
plasma feeds

Laser cannon
power generator

Thrust
vectrals

Starboard
repulsorlift

Rear compartment
can be sealed off in
case of emergency

Landing gear hatch

TANDEM ENGINES

For propulsion, Resistance transports rely on aftermarket engine
pods taken from Republic-era *Montura*-class shuttles, known to
be sturdy and reliable. Two miniaturized hyperdrives reverse-
engineered from First Order designs allow for faster-than-light
travel. Control linkages threaded between the passenger
compartments connect the engine pods, but breakdowns
are common and most transports carry astromechs to store
navigational data and keep the twin units in sync.

Passenger terminals

Modified civilian
passenger compartment

SJFS S/min-12a
hyperdrive (design
stolen from First Order)

Hyperdrive
power feed

Stabilizer fin
for atmospheric
flight

Cockpit
access tunnel

Durasteel hull

Heat
exchanger

Multi-layered
interference shielding

Rack-suspended
seats

Power
generator

Life support
systems

Sensor
array

Cockpit salvaged
from B-wing Mark II

Pilot escape hatch/
port docking hatch

NOT FOR ROOKIES

Transport pilots control their craft from a repurposed B-wing
Mark II cockpit locked in place and restructured to allow
for a docking hatch. The B-wing's life-support systems and
portside deflector shield projectors have been relocated
to within the adjacent cowling. This has reduced cockpit
visibility, forcing the pilot to rely on holographic visual
displays and a sensor suite to see the surrounding terrain.

SNOW SPEEDER

THE FIRST ORDER USES these versatile light utility vehicles for a range of missions on the Starkiller Base, from patrolling the perimeter to resupplying outlying stations with equipment. The snow speeder is a simple and rugged model: basically a pair of seats, a platform for cargo, repulsorlifts, and two turbines. Similar speeder trucks are a common sight on many worlds, but the military model favored by the First Order has a higher-capacity generator than civilian craft, upgraded power converters, and a mount and cable trunking to support a repeating blaster.

TOUGH ENOUGH

Temperature extremes are tough conditions for repulsorlift craft. Radiator fins dissipate the heat produced by power generators, but can fail to keep up in hot climates and shed too much heat in cold ones, resulting in generators burning out or locking up. The rugged snow speeder required little adaptation for the Starkiller Base, however: Its radiator fins were insulated to dampen the heat exchange and electrostatic baffles were added to keep ice particles out of the turbine intakes.

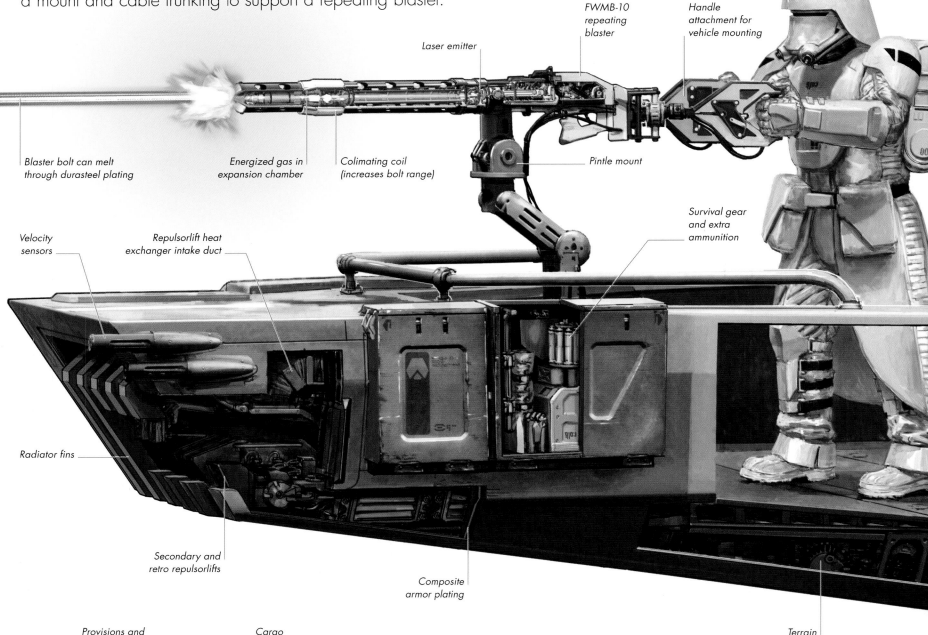

Laser emitter

FWMB-10 repeating blaster

Handle attachment for vehicle mounting

Blaster bolt can melt through durasteel plating

Energized gas in expansion chamber

Colimating coil (increases bolt range)

Pintle mount

Velocity sensors

Repulsorlift heat exchanger intake duct

Survival gear and extra ammunition

Radiator fins

Secondary and retro repulsorlifts

Composite armor plating

Terrain sensors

Provisions and ammunition

Cargo compartment

Control column

Extra fuel

Seat tractor beam emitters

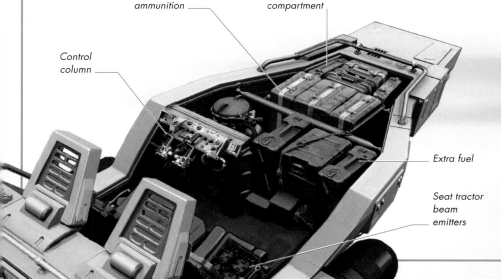

MISSION PROFILES

The speeder's gunner typically rides in the prow, scanning the horizon for targets. The repeating blaster's mounting attachment gives it a wide field of lateral fire, and it can be elevated or depressed to defend against both aerial threats and ground-based attacks. The blaster is easily removed and stowed for routine missions, with the speeder's prow instead used to transport equipment. Even while seated, the occupants are exposed to the elements and depend on heating coils built into their seats and thermal units behind them.

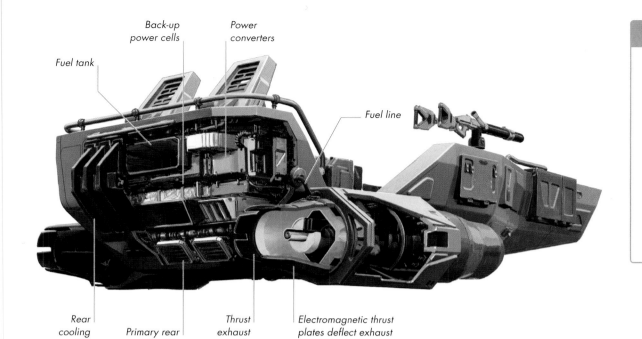

Back-up
power cells

Power
converters

Fuel tank

Fuel line

DATA FILE

> **MANUFACTURER** Aratech-Loratus Corporation

> **MODEL** Light Infantry Utility Vehicle (LIUV)

> **CLASS** Speeder

> **LENGTH** 5.33 meters (17.47 feet)

> **CREW** 2 (standard complement) or 3 (maximum)

> **WEAPONS** 1 FWMB-10 repeating blaster

> **AFFILIATION** First Order

Rear
cooling
fins

Primary rear
repulsorlifts

Thrust
exhaust
nozzle

Electromagnetic thrust
plates deflect exhaust
stream for steering

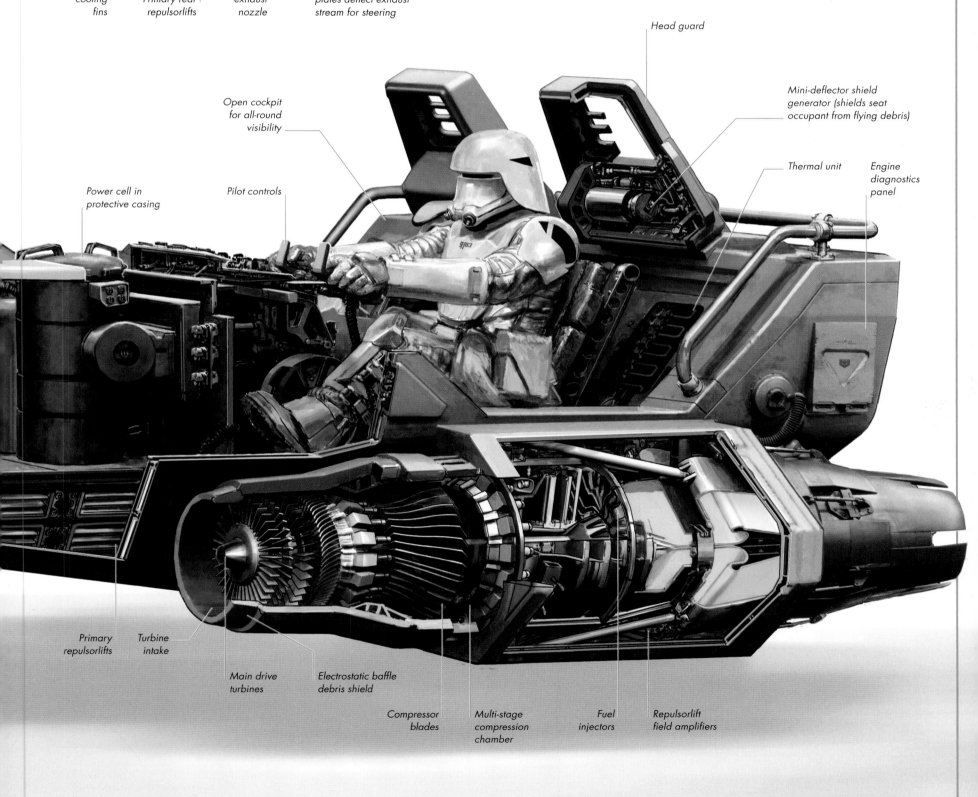

Open cockpit
for all-round
visibility

Head guard

Mini-deflector shield
generator (shields seat
occupant from flying debris)

Power cell in
protective casing

Pilot controls

Thermal unit

Engine
diagnostics
panel

Primary
repulsorlifts

Turbine
intake

Main drive
turbines

Electrostatic baffle
debris shield

Compressor
blades

Multi-stage
compression
chamber

Fuel
injectors

Repulsorlift
field amplifiers

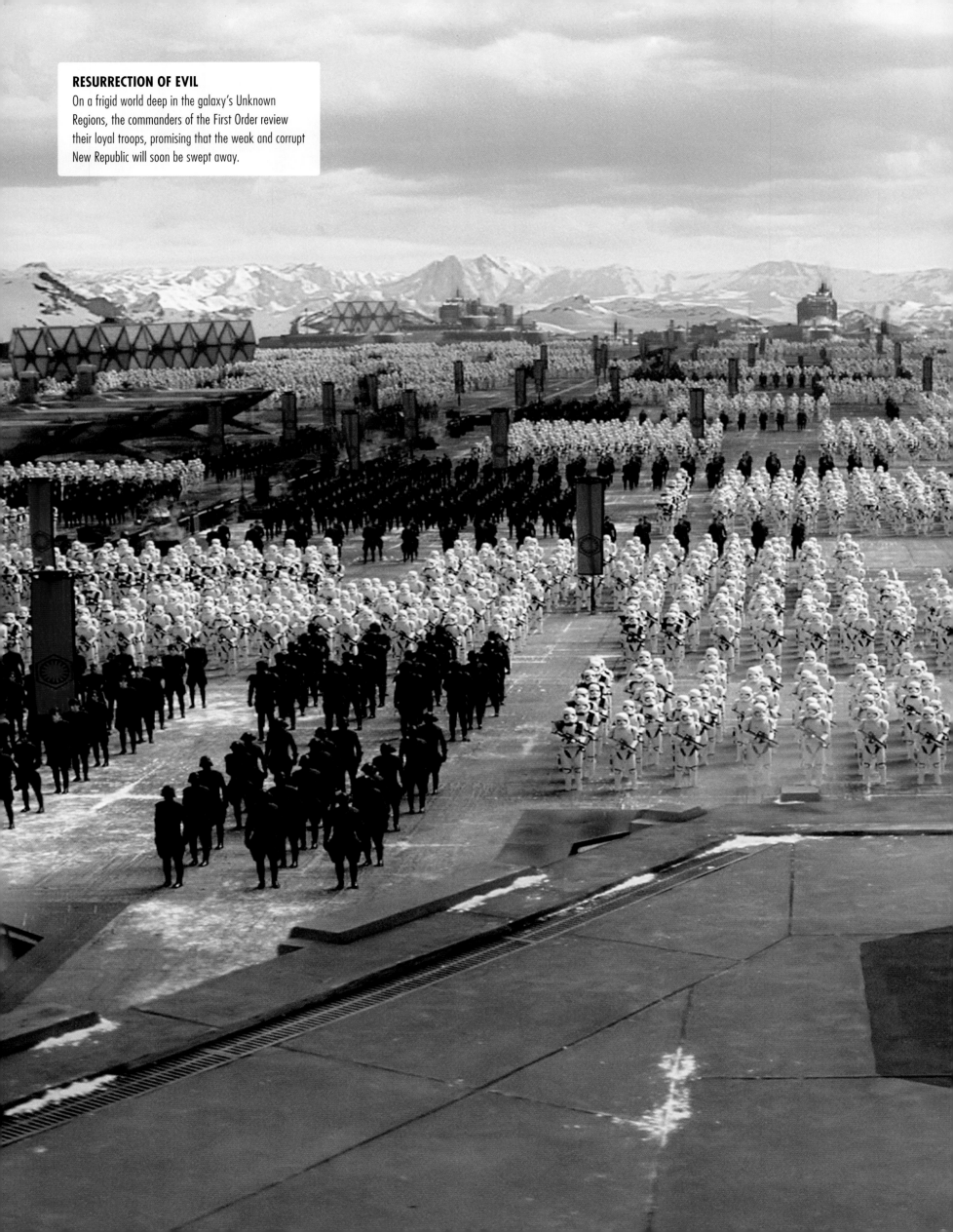

RESURRECTION OF EVIL
On a frigid world deep in the galaxy's Unknown Regions, the commanders of the First Order review their loyal troops, promising that the weak and corrupt New Republic will soon be swept away.

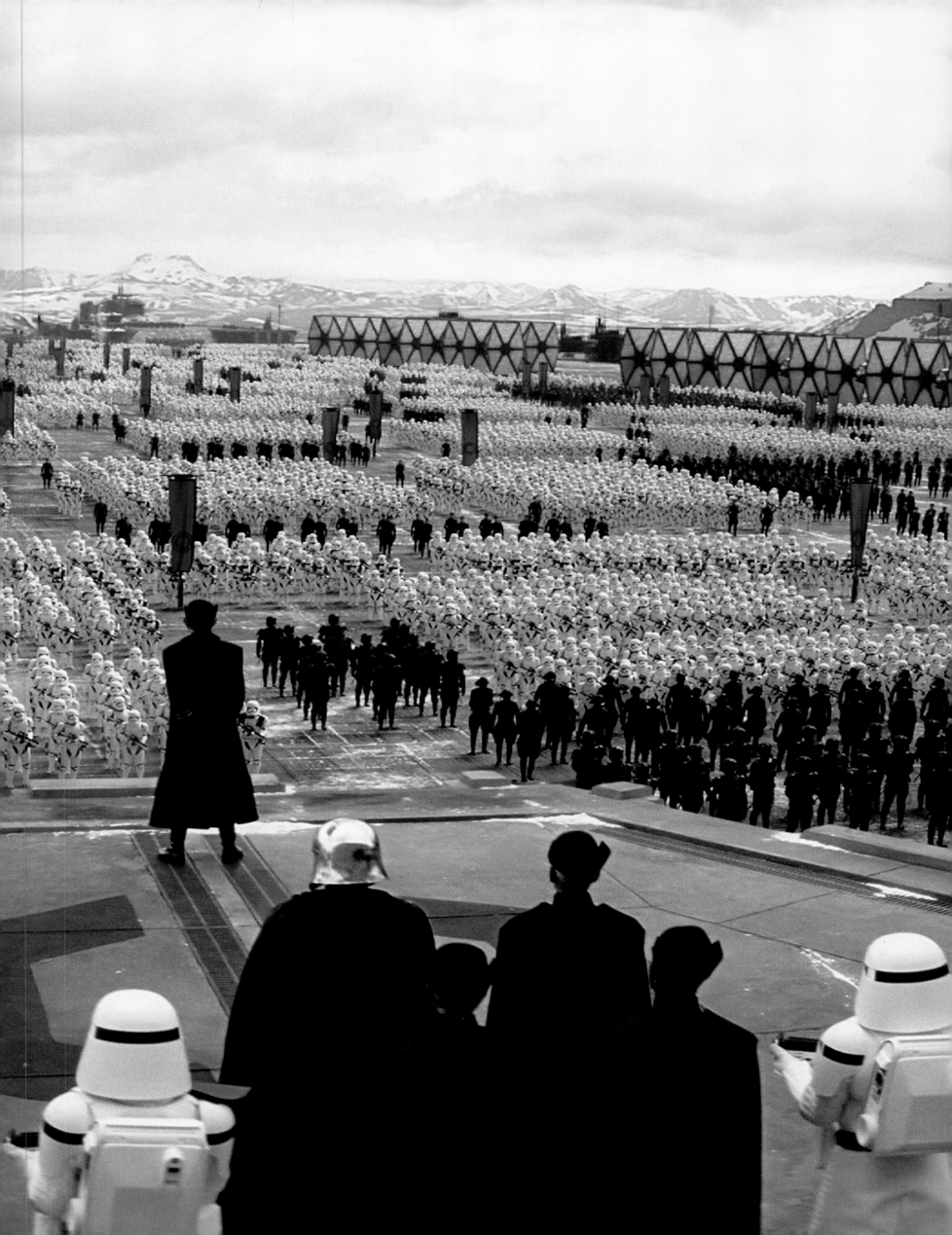

SIZE COMPARISON

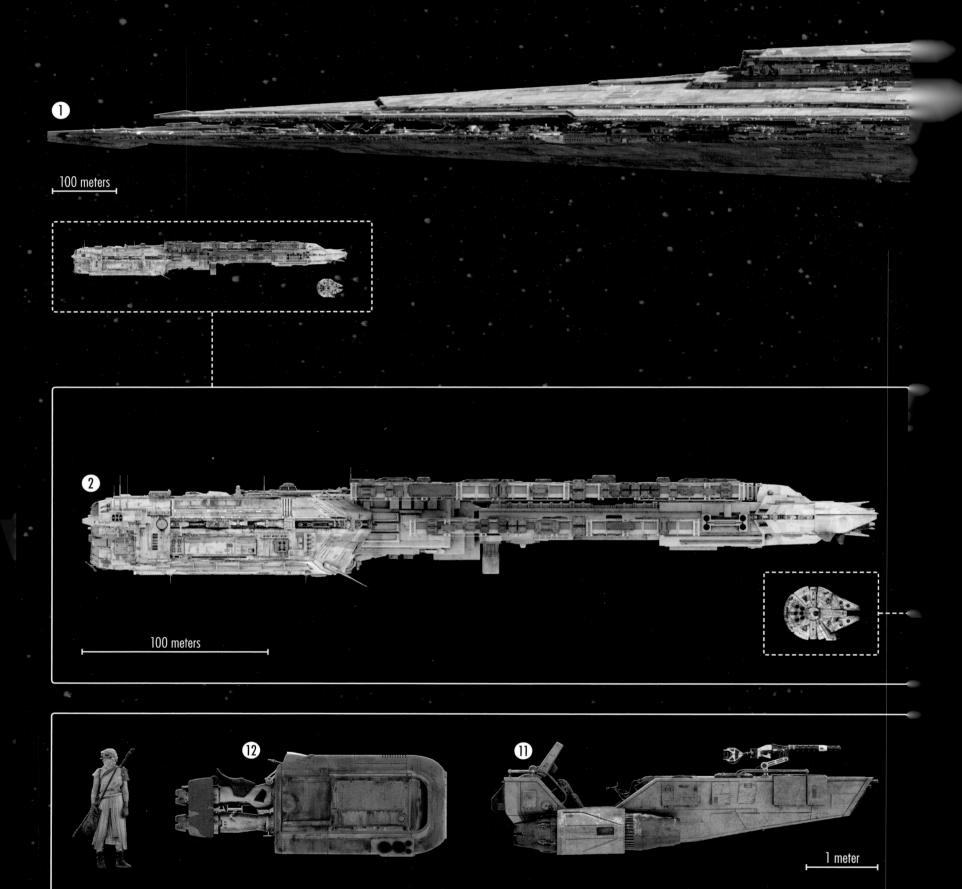

① 100 meters

② 100 meters

⑫ ⑪ 1 meter

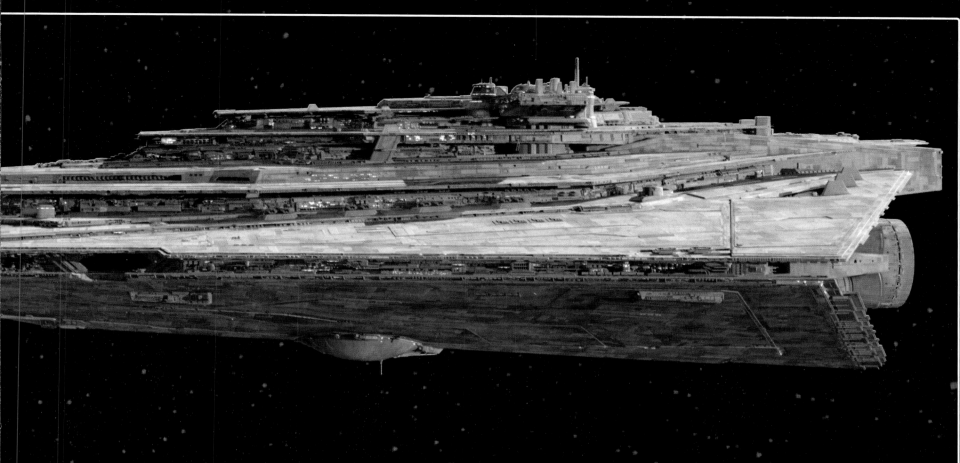

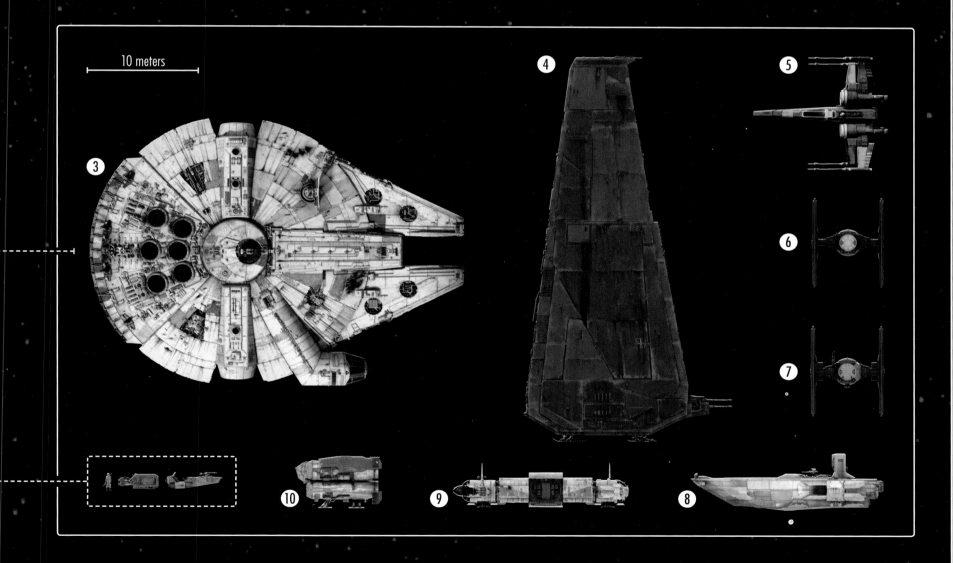

1. *Finalizer* Length 2,915.81 meters
2. **Han's freighter** Length 425.99 meters
3. *Millennium Falcon* Length 34.52 meters
4. **Command shuttle** Height 37.2 meters

5. **Poe's X-wing** Length 12.48 meters
6. **TIE fighter** Length 6.69 meters
7. **SF TIE fighter** Length 6.69 meters
8. **Stormtrooper transport** Length 17.83 meters

9. **Resistance transport** Width 16.18 meters
10. **Quadjumper** Length 7.98 meters
11. **Snow speeder** Length 5.33 meters
12. **Rey's speeder** Length 3.73 meters

10 meters

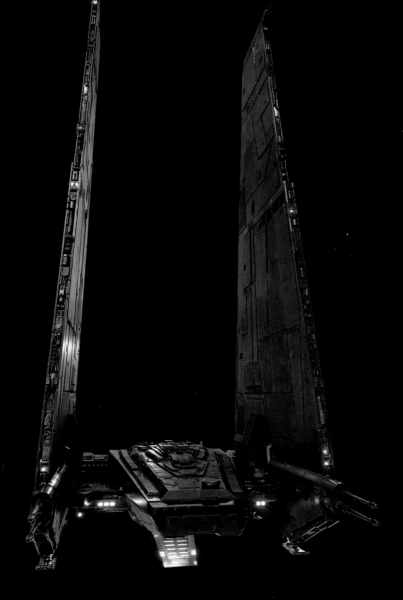

Penguin Random House

Project Editor David Fentiman
Project Art Editor Owen Bennett
Creative Technical Support Tom Morse
Senior Pre-production Producer Jennifer Murray
Senior Producer Alex Bell
Managing Editor Sadie Smith
Managing Art Editor Ron Stobbart
Art Director Lisa Lanzarini
Publisher Julie Ferris
Publishing Director Simon Beecroft

For Lucasfilm
Executive Editor Jonathan W. Rinzler
Image Archives Stacey Leong and Matthew Azeveda
Associate Technical Director Cameron Beck
Art Director Troy Alders
Story Group Leland Chee, Pablo Hidalgo, and Rayne Roberts

First American Edition, 2015
Published in the United States by DK Publishing
345 Hudson Street, New York, New York 10014

A catalog record for this book is available from the Library of Congress.
ISBN 978-1-4654-3815-7

DK books are available at special discounts when purchased in bulk for sales promotions,
premiums, fund-raising, or educational use. For details, contact: DK Publishing Special Markets,
345 Hudson Street, New York, New York 10014
SpecialSales@dk.com

Printed and bound in the USA

A WORLD OF IDEAS:
SEE ALL THERE IS TO KNOW
www.dk.com
www.starwars.com

ACKNOWLEDGMENTS

Kemp Remillard: First and foremost I'd like to thank Cameron Beck, Stacey Leong, Matthew Azeveda, and Chris Medley-Pole whose attention and help with Lucasfilm digital assets was indispensable in creating artwork for this book. Many thanks to J.W. Rinzler, Troy Alders, Pablo Hidalgo, Phil Szostak, Leland Chee, Newell Todd, Samantha Holland, Becca Friedman, Justin Chan, Mike Conte, Megan Matouzek, and everyone else on the 6th floor for their warm reception, hospitality, and help with Star Wars facts big and small. It's been a real pleasure working with such a great group here in San Francisco.

And of course, I'd like to thank Owen Bennett, David Fentiman, Tom Morse, and the team at DK in London for having faith in my promised ability to complete an essentially impossible art task, and for striking fear into my heart when they first asked me if I wanted to do this.

I would like to thank Jason Fry, whose collaboration on this book could not have been more enjoyable and for running with some of my crazy ideas.

I want to thank all of my good friends at Massive Black for teaching me the ways of the Force. I would also like to thank Hans Jenssen, Richard Chasemore, and everyone who worked on the original Star Wars: Incredible Cross-Sections for all the inspiration. Lastly, I have to thank JJ Abrams, Kathleen Kennedy, and George Lucas for making it all possible.

Jason Fry: Thanks to Pablo Hidalgo, Phil Szostak, Leland Chee, Jonathan Rinzler, and all at Lucasfilm for showing us such cool new stuff; to Jeff Carlisle, Ryder Windham, Chris Reiff, and Chris Trevas for ace Falconology; to Joe Johnston for, well, everything; to David and Owen at DK for keeping us on track; and to all the previous DK writers upon whose shoulders we stood. And, as always, to Emily and and Joshua for tolerating me.

DK Publishing: We would also like to thank Phil Szostak, Brian Miller, Natalie Kocekian, and Mike Siglain for their assistance with the creation of this book.

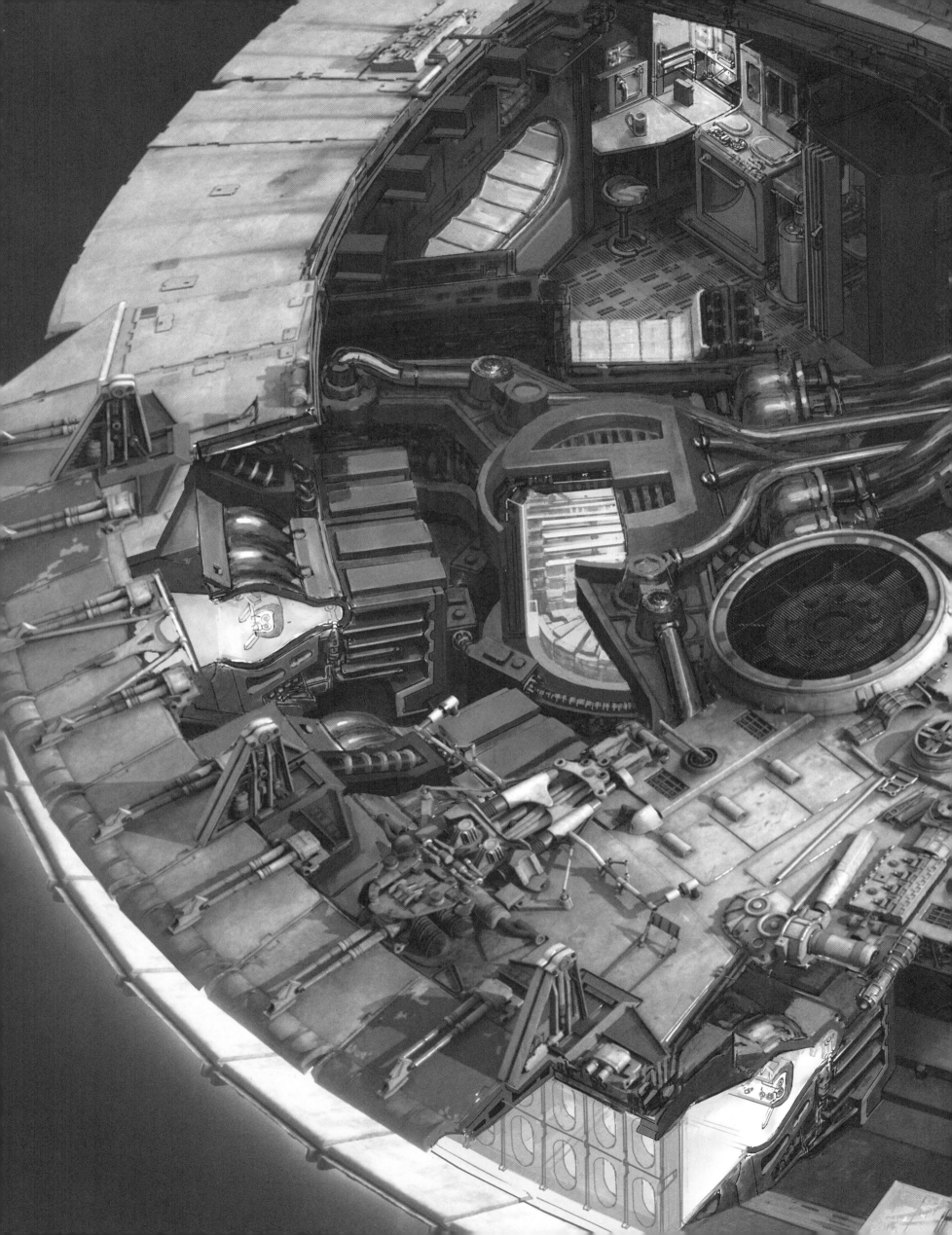